PARTING SHOT

THE RAILWAY PHOTOGRAPHS
OF NORMAN JOHNSTON

COLOURPOINT

Published 2015 by Colourpoint Books
an imprint of Colourpoint Creative Ltd
Colourpoint House, Jubilee Business Park
21 Jubilee Road, Newtownards, BT23 4YH
Tel: 028 9182 6339
Fax: 028 9182 1900
E-mail: info@colourpoint.co.uk
Web: www.colourpoint.co.uk

First Edition
First Impression

A catalogue record for this book is available from the British Library.

Designed by April Sky Design, Newtownards
Tel: 028 9182 7195
Web: www.aprilsky.co.uk

Printed by W&G Baird Ltd, Antrim

ISBN 978-1-78073-073-8

Front cover: It is the evening of Friday 30 May 1969 and WT Class 2-6-4T No 53 has just arrived at the old Portadown Station with
stock for next morning's Baptist excursion to Portrush, on which the author would be travelling. The arrival of a tank engine at
Platform 2 with eight carriages could have been like a steam train to Dublin any weekday in the early 1960s, so the past has been
recreated with a bit of mild deception.

Rear cover: Easter Monday, 17 April 2006 and No 186 departs from Whitehead with an 'Easter Eggspress' on the return working
to Belfast Central.

CONTENTS

FOREWORD

Norman Johnston – I wonder in what way I could possibly describe such an indefatigable human being. I think I just have to tell it like it is – and was.

So many people who will read this, his last book, will know Norman as a scholarly, meticulous researcher into, and writer about, the railways of this island, particularly the North. It was indeed his great interest and one that I shared with him, albeit as a less informed companion, throughout our thirty-nine years together. I sat on windy platforms while he waited for the next 'must-see-and-photograph' train. I held his cameras and lenses and carried them in my handbag (the "Why-on-earth-do-you-need-such-a-big-handbag?" bag!). I sat through endless railway enthusiast conversations on RPSI trains, and knew that when we got home Norman would be happily hoarse from talking so much in noisy carriages. He would arrange pleasant holidays and I would discover that, by amazing coincidence, there happened to be a preserved line just down the road. Illness as an infant left him with some walking limitations. However, I was always caught out by the speed at which he could navigate the length of a platform or even charge across a footbridge if a locomotive was showing steam on the horizon. In later years, when he used a mobility scooter, I was left far behind.

That is how so many people will remember Norman Johnston. But there was so much more.

Norman was a survivor of a near-fatal attack of polio at the age of eighteen months. I think this must have contributed to his zest for life, his interest in almost anything that crossed his path. He was an exuberant polymath, discussing and making notes on such disparate subjects as the universe, theology, archaeology, history, genealogy, the environment, car, bus and lorry manufacture. Just occasionally, I would have liked to have a husband who sometimes did nothing, even for half an hour!

But he was more than all this too.

He was a teacher in his first career, not letting any disability prevent him from a full and active school life. He was a Christian who served his church as Local Preacher, treasurer and hard-working layman. When he knew he was dying he put in his order to God for the new, better body he wanted when he arrived in Heaven. He was hoping to be re-boilered.

When he and I started Colourpoint in 1993, Norman was the financial backbone of our fledgling efforts, a role that grew in complexity as Colourpoint became a success beyond anything we had envisaged. He wrote, edited and managed tirelessly through the coming years.

But he was more than all this too.

He was a loving husband, father of two wonderful sons, and when he died he

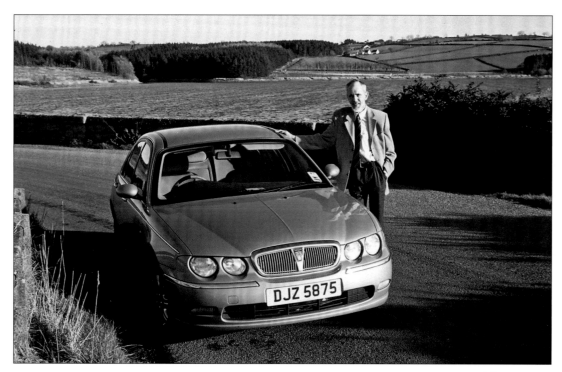

Norman with his Rover 75.

had known the delight and companionship of four beautiful grandchildren. The eldest, a little boy of six, said when his Grandpa died, "I have lost my teacher."

Norman was noticeably ill for about eighteen months and the deterioration was unstoppable. He has described in his Introduction how he came to decide to write this book. As I read his extended captions and the little bits of personal recollection and humour, I see that Norman's personality is all over this book. I watched him working hard at it as the two months he had been given slipped inexorably away. I brought him endless mugs of coffee, which seemed to help him give a little more when he was feeling weakest. It went so well that, with his ever-present humour, he commented to me one day, "I'd better slow down or this book won't be posthumous and I'll have to re-write the Introduction!"

But it is as he anticipated, sadly posthumous. At the end I couldn't hold his cameras, only his hand.

So these are the inadequate words I have to describe my husband. And yet still, he was so much more…

Sheila Johnston
2 March 2015

INTRODUCTION

I suppose it is not uncommon for books to be published posthumously, usually because the author has died while the book is still with the printer. This book is rather different in that it was planned from the very start to be posthumous. The idea of writing it came to me on 10 July 2014 when I was lying quietly in bed reflecting on my own mortality. I had known for some time that my cancer was untreatable, but three days previously I had been told by my Consultant that I had about two months to live.

When you receive news like that (and we all know people who have) it really focuses your mind on what is important and what isn't. I had no fear of death itself because it is a core Christian belief that there is a 'next life' and my gut feeling was that the 'next life' might be better than the earthly one (provided you boarded a train going in the Up direction and not a Down working!).

Anyway as it happened, that very week I had been looking afresh at my slide collection and creating a new catalogue of my early railway ones. In the past, I had contributed some of my pictures to other people's books, but it had never occurred to me to produce an album of them. So that night as I lay in bed, I was thinking "Would it be possible to write a book in eight weeks?"

Getting my two sons on board was vital because, although my wife and I had founded Colourpoint Books 21 years earlier, my two sons now owned the business

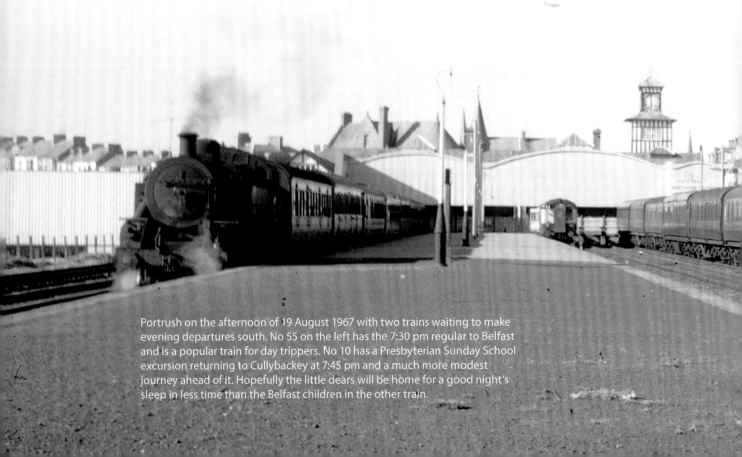

Portrush on the afternoon of 19 August 1967 with two trains waiting to make evening departures south. No 55 on the left has the 7:30 pm regular to Belfast and is a popular train for day trippers. No 10 has a Presbyterian Sunday School excursion returning to Cullybackey at 7:45 pm and a much more modest journey ahead of it. Hopefully the little dears will be home for a good night's sleep in less time than the Belfast children in the other train.

and called the shots over what to publish. When I broached the possibility of this book a few days later, Wesley said "Dad, you are actually in quite a strong bargaining position!" Both turned out to be quite enthusiastic about the project and to my delight it was 'a go'er' from day one.

I want to thank those who kindly agreed to proof read the book after it had been prepared for publication. This book would have been impossible without them and is all the better for their knowledgeable contributions. We have all agreed that author royalties will go to the RPSI fund for restoring GNRI Q Class 4-4-0 No 131. My only regret is that I will probably not live to see the 131 Project reach a conclusion.

Apart from a couple of early experiments, the photos appearing in this book were all taken between 1964 and 1973 and represent my earliest railway photos. This was a very interesting period to be a railway enthusiast, including as it did the last years of steam and the early years of NIR. The pictures are presented in roughly chronological order and include some CIÉ as well as UTA and NIR. Back in those days I took loads of photos out train windows and took loads on every RPSI railtour. However, very few in either category feature in this book, unless at more unusual locations. I have tried so far as I can to concentrate on the 'working railway'.

August 2014

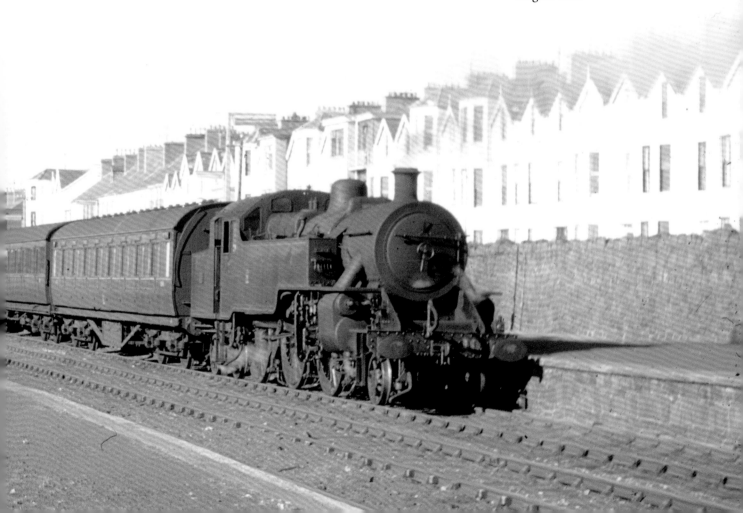

A note for the lay person
Readers of this book will see frequent references to 'up' and 'down' in relation to trains and platforms. In railway terminology the 'up' direction is towards the line's headquarters. Thus on the GNR(I) 'up' was towards Dublin and 'down' towards Belfast. On the NCC 'up' was towards Belfast and 'down' towards Larne, Coleraine, Londonderry etc, and on the Bangor line 'up' was towards Belfast and 'down' towards Bangor.

In signalling a 'home' signal was a red stop signal controlling entry to a station and a 'starter' signal was an identical red signal controlling departure from a station. A 'calling on' signal was a signal of smaller proportions, below a red 'home' signal at danger, indicating to proceed under caution but prepare to stop before the next signal or the bufferstop. This could be because of the presence of a parcel van etc.

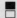

This was *almost* my first train photo but a suitable introduction to my father's part in this album. My family were staying at a Guest House in Dublin in 1961 and had gone to Bray for the afternoon on 28 July. I was 12 at the time and badgered my father to take a photo of the train we intended to return to Dublin on. This was a big ask, as he rationed himself to one 620 size film a year, taking eight photos, but he agreed. The photo captures the appearance of Bray in the early 1960s, when the service was run by green AEC railcars, supplemented by steam trains in the morning and evening rush hours. Here we are looking north towards the signal cabin and level crossing. Note the bicycles on the up platform, probably belonging to commuters and railwaymen. The four-car set includes one of the Bulleid designed Park Royal coaches, third vehicle from the camera in this view.

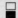

I started taking my own photographs at Easter 1962, using my father's lovely Kodak folding bellows camera which had a superb lens. As it happened, my first ever photo was a railway one and was this view of Omagh station. I am standing on the up platform, at 733 yards the longest on the GNR, and am looking towards the goods yard and the line to Newtownstewart. Note the heavy trolley full of mail bags on the right waiting to be loaded onto an up train. The boarded walk in the foreground provided a short cut for porters from one platform to the other but passengers had to use the footbridge. Little did I know then that, starting in 1972, I would spend 25 years of my working life in Omagh.

First Shots

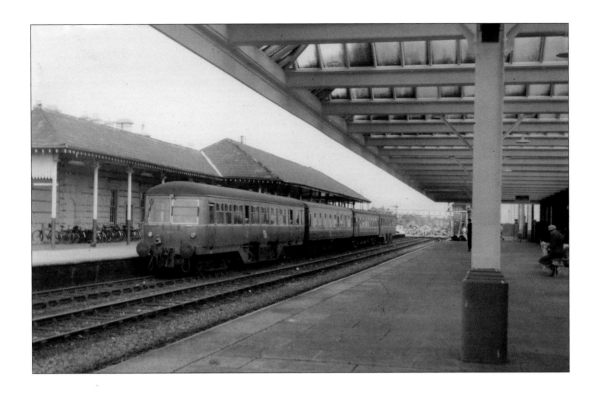

1964

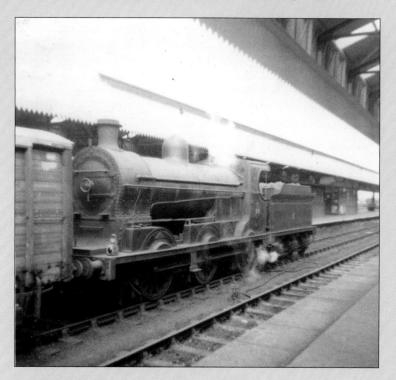

Later in 1962 I bought my first camera, a rather cheap Felicia one using 120 size film which gave 12 square pictures per roll. The lens was nowhere near as good as my Dad's one. Realising at the start of 1964 that steam was going to disappear and that the Derry and Warrenpoint lines were facing closure, I decided to take up some serious railway photography. The first engine I photographed was SG2 Class 0-6-0 No 38 on station pilot duty at Portadown on 17 February. In this view she is sitting at Platform 2, ready to attach a wagon to the rear of a railcar. Five weeks later, on 25 March, No 38 had a mishap at Portadown shed. The previous night she had been stabled in No 1 road of the roundhouse, with the cylinder cocks shut and the reversing lever in a forward gear rather than in the middle. A slight blow in the regulator gradually built up pressure and during the night she suddenly took off on her own and nose-dived into the turntable pit. Her front end took some damage and the NCC heavy crane was brought down to lift her. To my knowledge she never ran again.

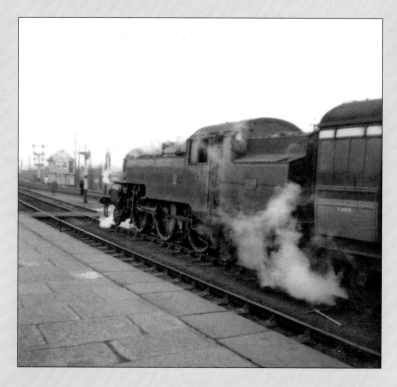

I was only 15 at the time and hoped to see a blue VS 4-4-0 on the Dublin train. I was a bit disappointed when the motive power on the 2:15 pm Belfast–Dublin turned out to be a 'Jeep', as we called the ex-NCC 2-6-4Ts. No 50 has just arrived at Platform 2 and will take water there before proceeding to Dundalk. The carriages are CIÉ-owned and C265N was an ex-GNR D2 Class Brake/First, built in 1922. It was scrapped in 1965. The background to the photo shows the barrow walk (very much used by passengers in preference to the subway), the Platform 2 starting signal, the South cabin and barely visible on the left the bridge over the Bann. The UTA at this time were fitting reconditioned boilers and new fireboxes in the 2-6-4Ts and in early 1963 No 50 was the first to get this treatment.

Thankfully I decided to photograph the two signal cabins at Portadown that day. 'Portadown North' was situated at the Belfast end of the island platform. This view shows the cabin as it was in 1964. Note the useful barrow walk from Platform 1. The carriage sidings in the background had more wagons than carriages that day. The oil tank wagon carried fuel for signal lamps. The starting signal for Platform 2 has also a smaller arm used for shunting movements. In 1967 signalling at Portadown was rationalised. 'Portadown South' was closed and 'Portadown North' enlarged with an extension to the end facing the camera, and controlled the whole station.

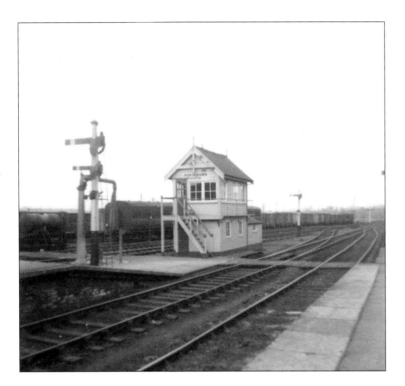

Portadown South cabin was situated just beside the Bann Bridge and was similar in style to Portadown North, though larger with six bays of windows compared to four and an additional window at ground level. The two tracks in the foreground lead to Platforms 3 and 4 with a crossover between them. To the left is the Platform 2 road. A very familiar sight from the passenger station was steam rising from engines shunting the distant goods yard or even the shed beyond. The goods yard lay to the left beyond the three arm signal. Beside the cabin is a bracket signal controlling access to Platforms 3 and 4 and smaller 'calling on' signals for shunting movements or if there was a van at the platform.

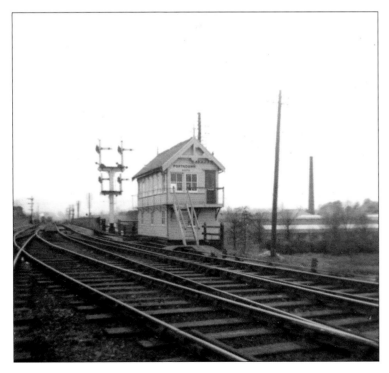

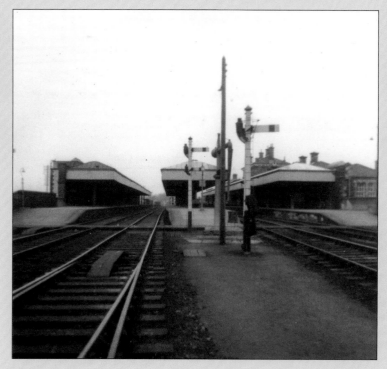

This is Portadown station viewed from the same position as the previous photograph but facing back towards Belfast. From left to right we have Platforms 4, 3, 2 and 1. There were two subways. The older of the two, linking only Platforms 1 and 4, dated from before the island platform was built and was closed in 1960. The newer subway served all four platforms. The long barrow walk at the end of the ramps is a feature that has long disappeared from NIR stations, but was immensely popular with passengers and staff. Platforms 3 and 4 were used by down trains and their water cranes were at the Belfast end. The signals here are the Platform 3 starter and calling on signals (for up trains using this platform) and the Platform 2 starter. Just visible at Platform 2 is single unit BUT railcar 121, of which more later.

The station clock indicates that it is early afternoon in this 17 February view of Platform 4. Passenger trains rarely used this platform after 1965, when it was used to provide facilities for the Customs men checking the paperwork on cross-border goods trains. The train is a bog standard AEC set in UTA green which is working the 12:55 pm Omagh to Portadown local. To the left is the extensively glazed waiting room serving Platforms 2 and 3 but there was also a buffet and bookstall.

Dun Laoghaire on 3 August 1964. I had just acquired my first 35mm camera and was on holiday in Dublin. This was my first ever colour slide of a train. Metrovick Co-Co No A48 has just pulled into the station with an up train, possibly the 4:15 pm from Bray. The carriages are in CIÉ green and are very elderly gas-lit vehicles. Despite the bash above one of the cab windows, A48 looks pristine in the black and tan livery which first appeared at the end of 1961 and was applied to both locomotives and carriages. The arrival of the General Motors B141 Class at the end of 1962 led to the A Class being largely relegated to goods trains and from 1964 on they were painted in a drab plain black livery.

About an hour after the previous shot, BUT railcar 121 arrives 'on its lone' at Platform 2. The platform staff called this train the 'Doodlebug', a nickname associated with the 'flying bombs' targeted at London in 1944. It was actually the 2:55 pm Belfast–Portadown local, a lightly loaded train that didn't need more than the 56 seats provided by No 121. The UTA had 14 BUT railcars, the 'Enterprise' express and the two Derry Road sets each requiring three power cars. Four of the remaining five cars were used to provide two smaller 3 or 4-car sets, each made up of two power cars and one or two trailers. The fifth car became the 'Doodlebug' for duties such as this. As a single unit it had no steam heating and relied on heat from the two AEC engines. Platform 1 to the right has all the usual signage and platform furniture from this era, the long sign identifying the General Waiting Room.

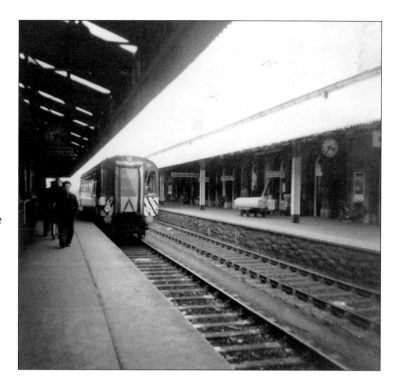

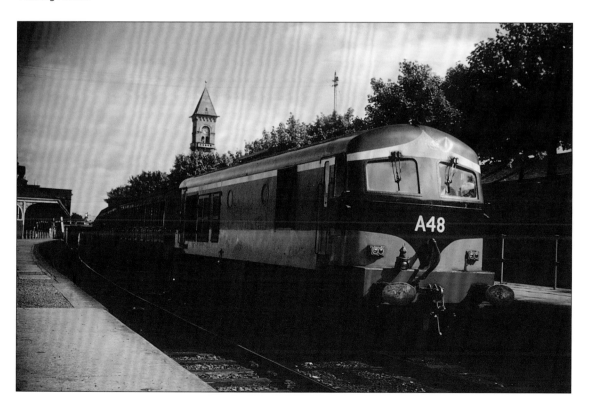

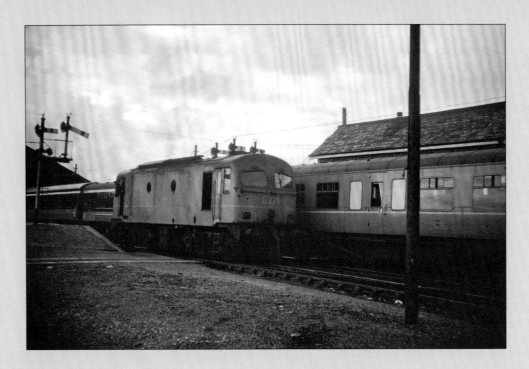

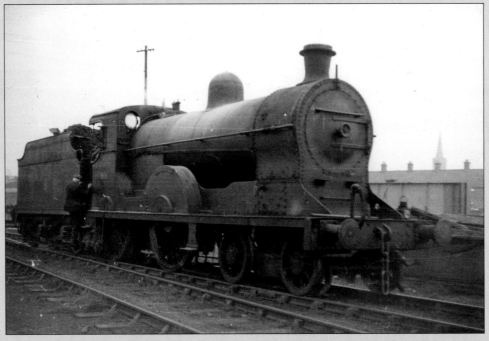

The black and white pictures reproduced here and in the pages that follow were taken with my 35mm Halina 35X camera, but the film suffered from two problems. I was relying on a borrowed and faulty light meter which was giving false readings and left most of the pictures too dark to even print. Worse still, the chemist who processed them didn't remove dust and hairs from the negatives before printing and also managed to scratch the negatives. However, since they are my only pictures recording the last days of GN section steam, I hope my readers will forgive me reproducing the best of them.

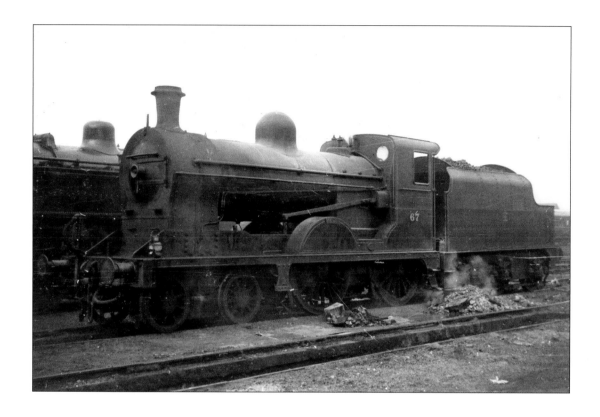

Limerick on 4 August 1964. The family was at Limerick on a day trip from Dublin. On the way there I had seen withdrawn 0-6-0s 262, 104, 195 and 124 at Thurles, but unfortunately I hadn't my camera out. After a bus trip out to Shannon Airport I was delighted to find green-liveried C228 sitting at a platform in Limerick station and had the cheek to ask the driver to move the engine forward clear of the platform so that my photo would show the bogie detail! This is what is happening here. It was the only slide I ever got of a CIÉ engine in green livery.

A visit to Adelaide shed around lunch time on Friday 30 October found several locomotives being prepared for afternoon duty. At last I got some 4-4-0s, though sadly not one of the two remaining VSs. *Lagan* was out somewhere and No 207 *Boyne* was tucked safely in the shed. With the locomotive already facing in the up direction, the driver climbs aboard S2 Class 4-4-0 No 63 *Slievenamon*. She is

coupled to one of the high sided D1/D2 tenders with flared tops built in the 1930s and the presence of the right-angled hand grip tells us it was once paired to a Compound. As GNR No 192 before 1959, she had proudly worn the famous blue livery in her heyday.

Like No 63, *Louth* still carried her nameplates right up to the end. She was the most active of the three remaining U Class 4-4-0s in late 1964 and was also in steam that Friday. I had reached Adelaide on the 12:50 pm Lisburn local, hauled by UG 0-6-0 No 49, if I remember correctly, so this shot was taken about 1:30 pm. The Jeep alongside is No 8, normally a York Road engine, but drafted in that Autumn to help keep the GN section running. The U Class 4-4-0s were close to my heart because in the 1950s, when they were in blue livery, I regularly travelled behind them in my native Fermanagh. At Adelaide, ash from locomotive fireboxes was deposited on the ground between the shed roads, as seen here.

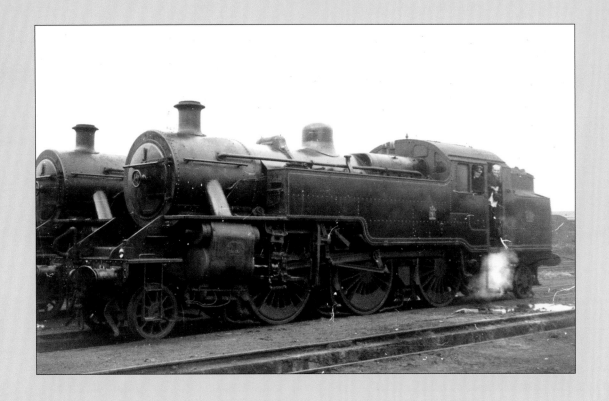

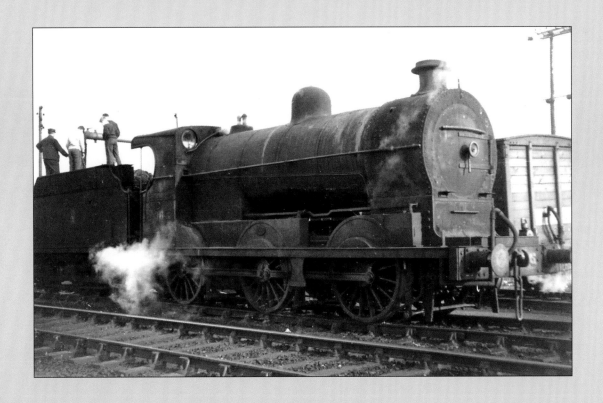

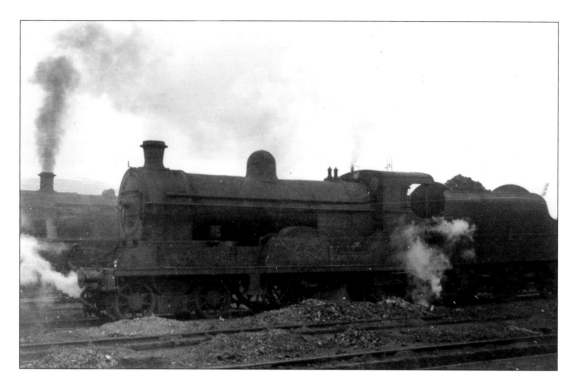

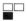

That afternoon, No 8 was being prepared to haul the 2:15 pm Dublin train as far as Dundalk. The driver, Fred Moore, was a neighbour in Portadown and a Fermanagh man himself. My mother had been a Moore, though not related to Fred. Alongside is No 1, another York Road engine in the early 1960s but now loaned to Adelaide. Both returned to York Road the following Spring. Fred invited me onto the footplate for the short run round to the coaling stage to top up the bunker. It was my first footplate trip and, although I took a picture of the operation it is not good enough to use in a book. Sadly, neither Nos 1 nor 8 were selected to receive reconditioned boilers and were among the eight 2-6-4Ts withdrawn in 1966–67.

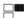

This photo was taken at Portadown station on Monday 2 November when I was waiting to go to Lurgan on the 2:44 pm train (the 12:10 pm from Londonderry). SG3 Class 0-6-0 No 36 arrived light engine from the Lurgan direction and stopped at the end of Platform 1 to take water. A few minutes later sister No 37 arrived alongside and took water from the Platform 2 crane. One of these was the engine that made a daily trip working each morning from Portadown to Lurgan to deliver wagons for unloading, shunt Lurgan yard and collect wagons that

were being forwarded. The other had possibly been at Adelaide shed to receive some mechanical repair and was being returned. Neither had been at Adelaide the previous Friday. Both engines would probably work Derry Road goods trains that evening. The teenagers on top of the tender had been allowed up to watch the operation. Health & Safety eat your heart out!

This picture was taken on another shed bash to Adelaide. It was Saturday 28 November and the previous two Saturdays had seen shed bashes to the Portadown roundhouse, neither producing any printable results! At Adelaide a rather woebegone No 174, clearly ready for action, was the first sight that greeted me when I arrived. She was so dirty I had to go to the front buffer beam to confirm the engine number. This was one of the three S Class 4-4-0s purchased from CIÉ in June 1963 (170, 171 and 174) and the nameplates were removed before they came north. No 174 *Carrantuohill* had been the last engine to receive an overhaul at Dundalk and Pearse McKeown and Paddy Mallon had made sure she received blue livery and a GNRB crest on the tender flanked by the big 'G N' letters. In her last few months of 1964 however, a black roller bearing tender had been substituted. This view, more than any other I took, captured the dirty working conditions railwaymen had to cope with at engine sheds.

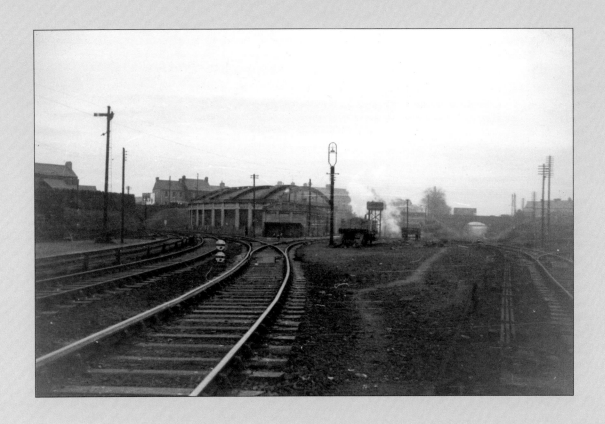

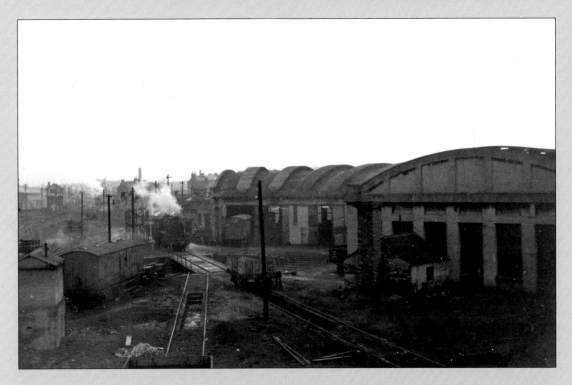

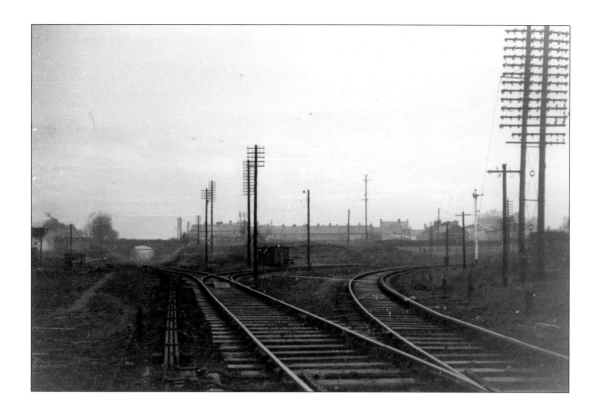

This picture and the next two were taken a fortnight later on 11 December 1964. For this picture I had walked past the shed and was standing on the gravel between the Dublin main line and the Derry Road, so I didn't have to cross any running lines apart from the track that engines used to enter the shed. I am right beside the Junction Cabin and probably spoke to reassure the signal man. In 1964 the UTA was more laid back about photographers than NIR would be today in this litigation obsessed age. To the left of the double track main line is the Gordon siding that ran parallel to it round the shed curve. In the far distance on the right, a lorry in West Street is crossing the brick bridge over the former Armagh line. This line was once double track but by 1964 was reduced to a single track 'one engine in steam' line to the Metal Box Co factory on the Brownstown Road which still generated some business for the railway.

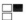

Portadown shed was conveniently accessible from West Street. There was a pedestrian gate in the fence, from which a steep path led down to the shed. Lighting conditions were poor in December so my picture is not as good as shots from the same vantage point in the summer. The engine approaching the turntable is ex-NCC 2-6-0 No 97 *Earl of Ulster*, by that time the last Mogul still operating. She had become a bit of an icon to this 15-year-old schoolboy. In the left foreground is an ex-DNGR six-wheel passenger brake. This vehicle had sat for many years beside Enniskillen shed and a colour picture of it appears later in this book. In the far distance we have 'Portadown Junction' signal cabin and the two upper pictures show the lines it controlled. The wisp of steam to its right comes from an engine shunting in the goods yard.

This picture shows the sharp curve of the 'Derry Road', which not many years earlier had also been double track. On the right is the home signal for traffic joining the main line at the Junction. On 11 December the 'Derry Road' was only nine weeks away from closure and the Brownstown Road siding would also be swept away as the UTA abandoned virtually all internal goods traffic. Soon Mogul No 97, whose steam is visible on the left, would cease its daily run up the Derry Road too and our little corner of the world would be changed for ever.

1965

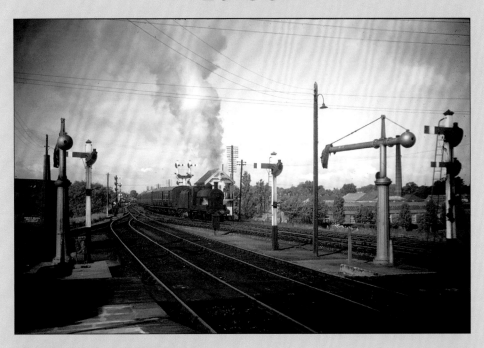

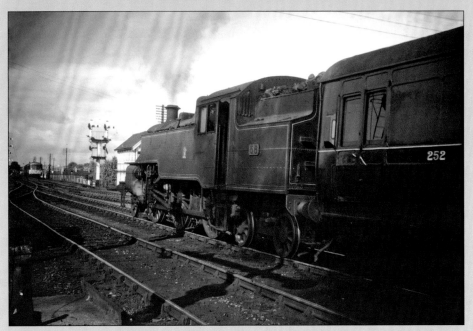

1965 was to be a down year in my life for railway photography. The spring was dominated by studying for O-Level GCEs and in July I was in Musgrave Park Hospital again for an operation. August through to October saw me on crutches and then a walking plaster. My only photo opportunity was at Portadown on 19 June when I took two slides, reproduced here.

While I was in hospital, the new regional liveries were introduced so I saw the BUT Enterprise in its new blue and cream scheme. I didn't have an opportunity to see either the Northern Region red and ivory or the Down Region green and cream. The green shade used there was similar to BCDR locomotive green. In all cases the UTA crest was replaced by the letters 'UTA' in yellow.

1966

This will be a familiar picture to a lot of readers, as the left hand part of it was the cover picture of Ian Sinclair's *Along UTA Lines* and it might also have featured in the ColourRail catalogue. It was actually my first colour slide of a steam train and my only slide of a GNR engine in action in pre-preservation days. The date is 19 June 1965 and gives a good panorama of the south end of Portadown. On the left is the 'Bann Siding' and the Platform 1 starter and water column. To the right of the four arm signal and left of the last carriage is the now silent goods yard. Just above UG 0-6-0 No 49 is a nice bracket signal with the calling on signal for Platform 4 in the 'off' position. Two Sunday School excursions for Bangor were dispatched from Platform 4 that morning and No 48 has just left with the first. No 49 had been waiting at Platform 3 for her turn. She has reversed her train back to the Bann Bridge and was now moving over the points into Platform 4 to pick up her load of eager passengers, all armed with buckets and spades, water pistols, etc, or the money needed to buy them when they reached Bangor. I had been on a similar excursion the previous Saturday.

As mentioned above, I had gone on a similar excursion to Bangor on 12 June and as I was sitting in the train, waiting for the guard to wave the green flag, the 8:10 am Dublin train came in with VS 4-4-0 No 207 *Boyne* at the head. I had been trying to get a picture of this engine the previous year but without success,

mainly because I didn't know what services she was rostered for. Why didn't I ask? I quickly realised that if I came to Portadown station before 9.00 am the following Saturday, I would get a slide of this elusive engine. When WT 2-6-4T No 56 turned up, I was disappointed but photographed it anyway. An AEC railcar has the calling on signal to enter Platform 4. The carriage next the engine is one of three 1938-built I4 composite/brakes, which donated their frames to MPD railcars 63–65 in 1961–62, and is running here on a GNR frame. No 56 got its reconditioned boiler in late 1964. Later, in July, when I was at Musgrave Park Hospital for an operation, I saw *Boyne* regularly, heading off to Dublin around 8:30 am. In the evenings I went out in my wheelchair around 8:30 pm to see her coming back in. I was delighted when the crew started waving to the lone figure in the wheelchair and blowing her whistle in greeting. Unfortunately light was fading by that time and 25 ASA film was not powerful enough for a photo.

As an impecunious 17 year old, I was unable to afford the price of the tickets for the RPSI's Province of Leinster Railtour on 14 May 1966. However, I did go down to the station to see the train coming through. No 54 was at the head and was the cleanest Jeep I had seen up to that time. It had only just received a re-conditioned boiler. The leading coach is 593, an AEC fitted L13 brake/third. In the carriage sidings in the background are a GNR K13 side corridor third and a Y6 van. A CIÉ luggage van lurks behind the signal cabin.

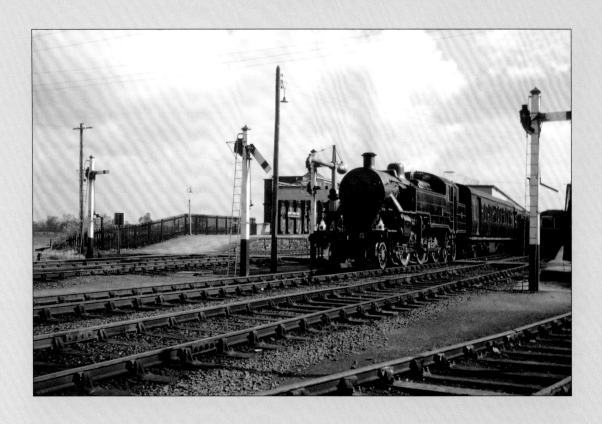

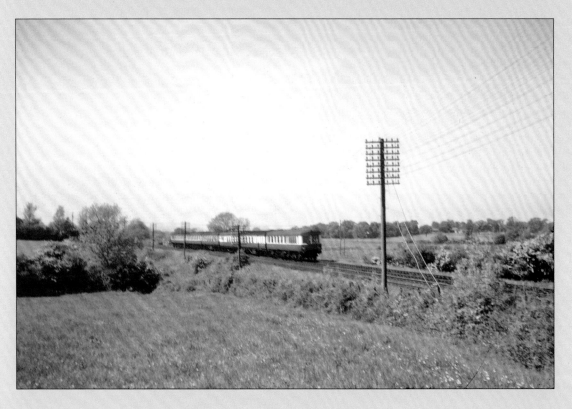

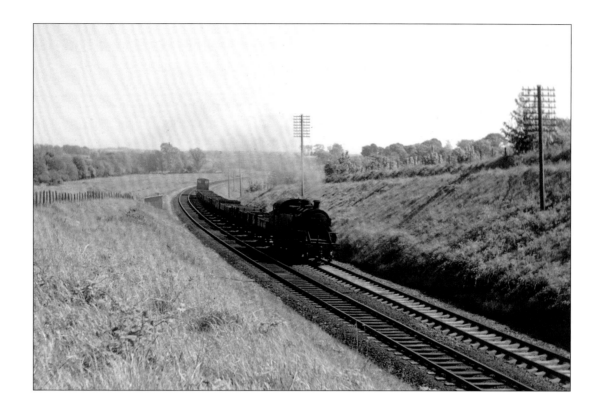

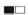

After taking water at Platform 2, No 54 made a spirited departure for Dromin Junction. Note the AEC railcar at Platform 1, wearing the new blue and cream. Neither the Northern nor Southern Regions made much attempt to avoid having green vehicles in the re-liveried sets so the other two vehicles in the set are probably green. The Down Region was much more diligent about this, marshalling their vehicles in three car sets of green and cream.

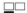

The only exception to this on the Southern Region was the 2.30 pm BUT Enterprise and I am including this shot at Knock Bridge on Monday 30 May, even though the speed of the train challenged my top shutter speed. The leading car is 131 and the second and third vehicles are D5 brake/first 562 and B6 dining car 552, the latter now in RPSI care as GNR No 88. On Saturdays two green-liveried vehicles were added to the rear and spoiled the all-blue effect. Knock Bridge, three miles south of Portadown, was once a popular location for railway photography but the volume of fast moving traffic at this bridge means you would be taking your life in your hands to try a shot like this today. In any case, railway embankments have become overgrown with bushes since steam traction ended.

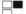

Not long after the passage of the up 4:00 pm Portadown–Dundalk CIÉ goods, I was surprised and delighted to hear the whistle of a steam engine coming in the down direction. It turned out to be a rather grimy No 51 on a ballast train and I include the shot, even though it had to be taken into the sun. Adelaide in the summer of 1966 still had 2-6-4T Nos 51, 54 , 55 and 56 on its books as well as UG Class 0-6-0 Nos 48 and 49 and SG3 0-6-0 No 37. The other Jeeps were based at York Road or stored out of service.

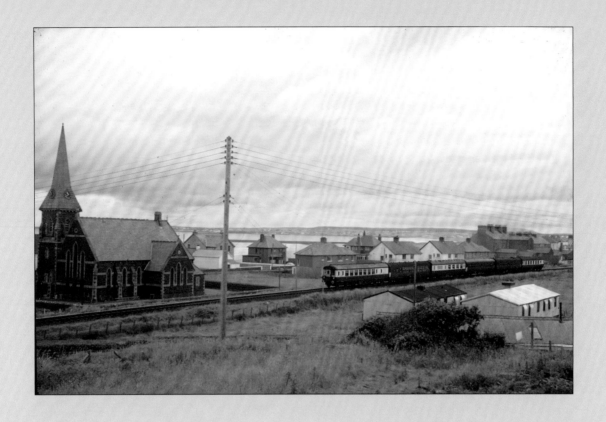

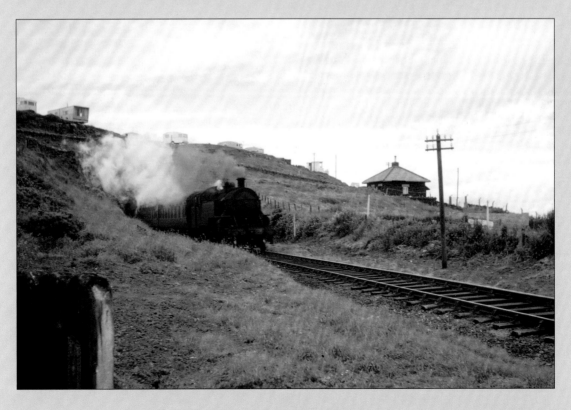

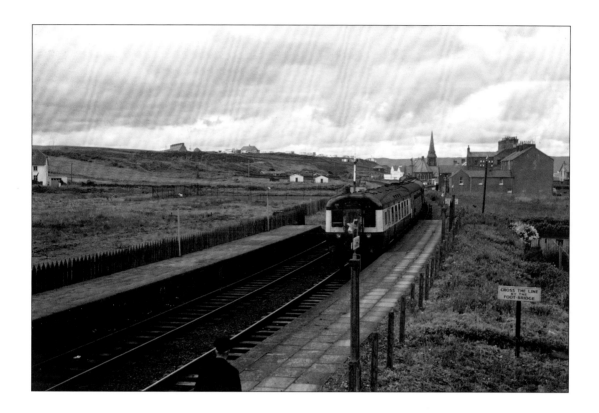

At the start of July I was staying with my Castlerock cousin. I arrived on Friday and at 8:30 am the next morning saw 2-6-4T No 3 passing with the 5:55 am Belfast–Derry, a train mainly used for carrying the day's newspapers. I dressed and got out as quickly as I could and was able to photograph two steam-hauled Derry–Portrush excursions, hauled by Nos 53 and 10, though neither shot merits inclusion in this book. This MPD is the 8:50 am non-stop Belfast–Londonderry express and is in the usual mix of liveries that characterised the Northern Region. The two leading cars are Nos 65 and 62 and the third is NCC Dining car No 548, built in 1924 and modernised in appearance by rebuilding in 1960. The power cars at the rear are 45 and 38. Portstewart is on the horizon across the bay.

2-6-4T No 3 bursts out of Castlerock tunnel with the 1:05 pm Londonderry–Belfast, one of a very small number of main line trains timetabled for steam in the summer of 1966. The two leading coaches

are from the 1934–35 North Atlantic express stock, characterised by very large picture windows with LMS 'middle period' sliding ventilators. The other main line set must have been using North Atlantic diner 549 as No 550 was being prepared for the launch of the new 70 Class set two days later.

The return working was the 11:30 am ex-Derry and I took this view from the cabin. The tunnel mouth can be seen just below the down starting signal. Today the whole area to the left is covered by housing. Cars 38 and 45 lead this set and the third vehicle is one of the J16 side corridor thirds in the 529–34 series. All were originally part of the 1951 Festival stock.

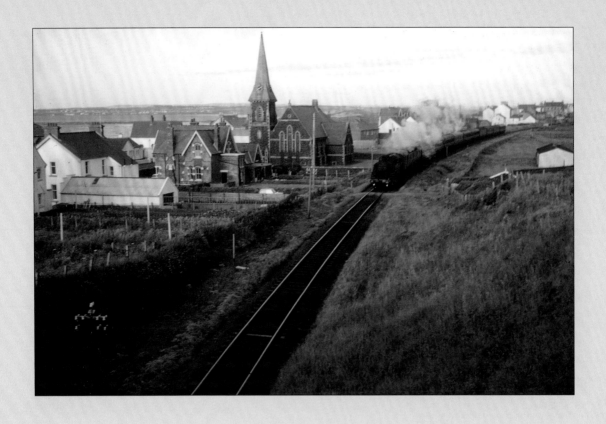

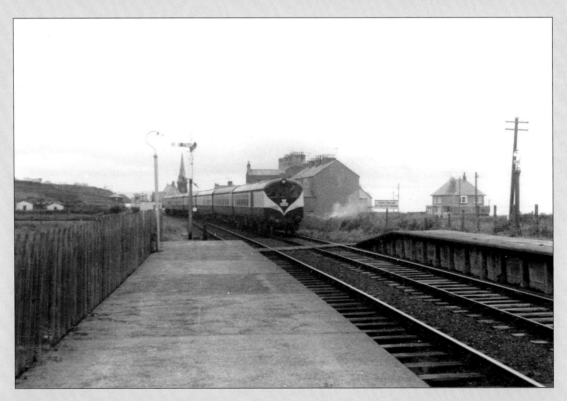

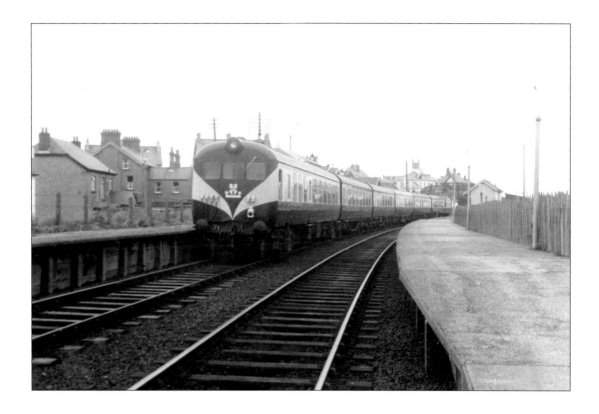

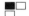

An evening view of No 10 working back to Derry on the return working of one of the two Portrush excursions mentioned earlier. The load is an amazing eleven carriages and a bogie van. This gives a very good panorama of Castlerock in 1966. The church beside the train is Castlerock Presbyterian. While I was in Castlerock I bought an old sepia postcard taken from the same vantage point but pointing slightly more to the right. This showed that there was once a siding running from the station to a quarry out of sight in this view. The track bed is just visible above the roof of the white-gabled shed on the extreme right.

The next 20 pictures were my first experiment with black and white film in the new camera.

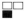

The signalman at Castlerock had told me that a brand new diesel electric train was entering service on Monday 4 July and this provided another photo opportunity. The press had been invited to travel on the new train and hopefully give glowing reports

of it. I missed the first down working but was at the station in good time to see the 11:05 am ex-Derry, seen here slowing for the Castlerock stop at 11:38. The leading power car is No 72 and the third vehicle is diner 550 which had been refurbished, cabled for 70 Class working, and its bogies fitted with SKF roller bearings like the rest of the train. This dining car is also in the present RPSI fleet as NCC No 87.

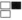

The other three carriages were side-corridor Seconds in the 721 series. I was most impressed by the quietness of the train (soon to change after several months of service!) and how well turned out the six-car set was. At last the UTA seemed to have a really modern passenger train and were beginning to accept that diesel-electric traction was the future. I was used to the impressive CIÉ diesel-electric locomotives and until 4 July the UTA had been very much the poor relation. Apart from diner 550, the whole train was brand new, or so it seemed. However the trailers had under-frames recycled from NCC J11 compartment Thirds brought over from the LMS during the War years. This new train was urgently needed in the summer of 1966 as MPD and MED reliability reached an all-time low.

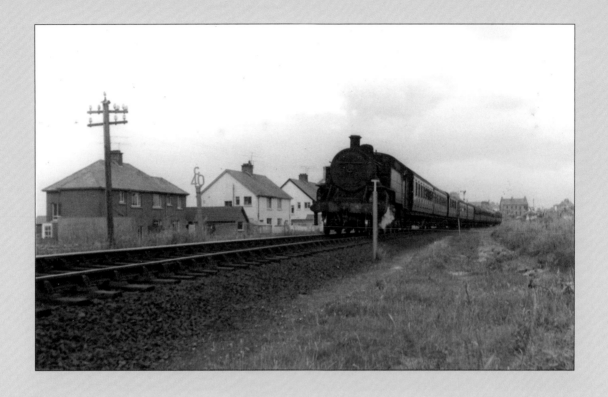

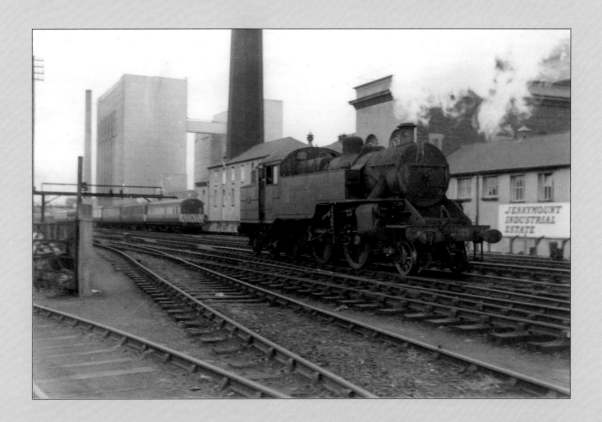

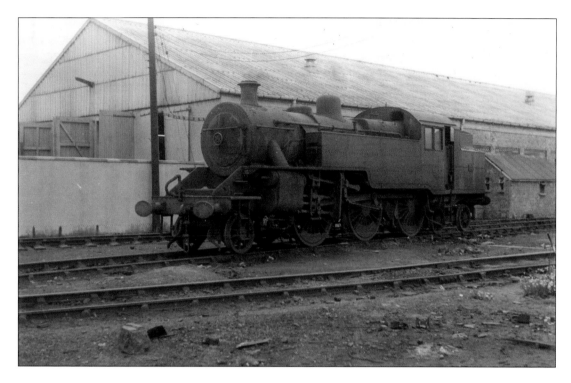

The signal man tipped me off that a steam train would be passing in the down direction at 1:50 pm. At Castlerock, the train had to stop to allow the 1:05 pm ex-Derry through. This was a three car MPD but my photograph of it is too poor for publication. No 4 had a ten-bogie load and was a Belfast–Londonderry excursion, though the participants would have had only the afternoon in Derry. Castlerock had a 40 mph speed restriction for non-stop trains and the signs in the foreground show the Commencing and Terminating points of this for up and down trains.

The next 17 pictures were taken on my first 'shed bash' to York Road on Thursday 11 August 1966. I was actually there to meet the legendary Harold Houston who had witnessed the arrival of the first W Class 2-6-0 in 1933. Mr Houston was still on the UTA pay roll and had his own little office near the running shed. He had the grand title of Curator of Historic Relics. He and I had corresponded for several months on NCC locomotives and he was anxious to meet this young enthusiast. He tipped me off about the useful footbridge linking Ivan Street to Milewater Road that still straddles the running lines and gave me directions to reach his office. My main regret was that it never crossed my mind to photograph the great man himself.

R M Arnold in *NCC Saga* commented that on 13 August 1966 the UTA resurrected 2-6-4T No 57 for one day to shunt York Road while other engines took specials to the Maiden City. However, she had already been resurrected the Thursday I was there and this view shows her reversing sharply past Jennymount Industrial Estate. The carriage siding in the background contains a rake of MPD vehicles, mostly in green livery. No 57 was one of the Jeeps overhauled in 1963 but had not been treated to a reconditioned boiler with new firebox.

Several interesting Jeeps were at York Road that day and I was particularly pleased to 'cop' No 52 even though it had already run its last mile. This was a very popular York Road engine and was the only one in the 50–57 series not to be transferred to Adelaide in the 1959–63 period. In fact, when Adelaide needed more Jeeps in 1964 it was those like 1, 7, 8 and 9 that were sent instead.

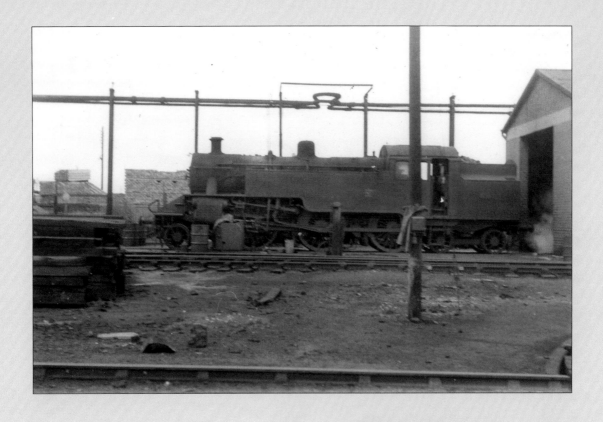

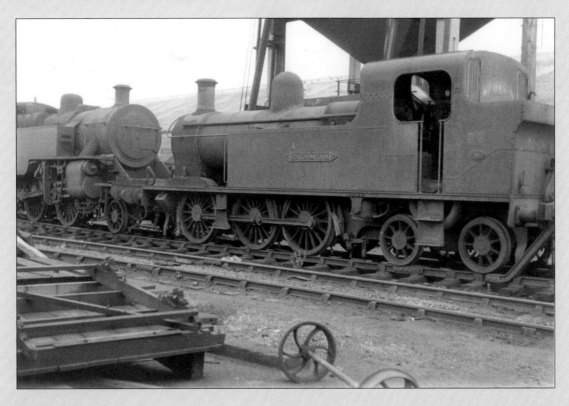

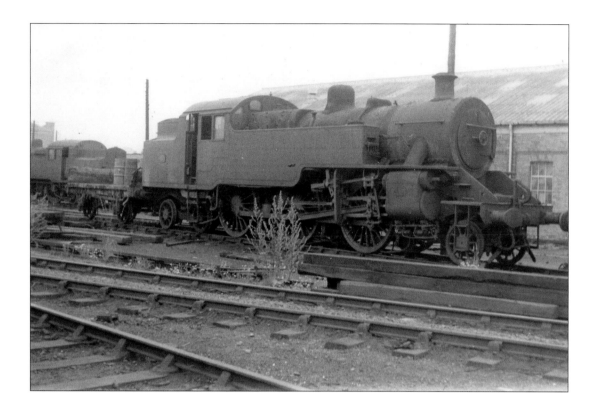

Another Jeep that was near the end of its working life that day was No 1, with only three weeks left until withdrawal at the end of August. I had last seen her in action at Adelaide in 1964.

There were two Z Class 0-6-4Ts at York Road that day, though sadly No 26 *Lough Melvin* had not been overhauled to join her sister for the last four years of UTA/NIR steam. She is wearing the plain black livery she bore while at Adelaide in the early 1960s. In the background is withdrawn 2-6-4T No 2, already with some of its fittings removed.

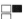

2-6-4T No 8 was the Jeep on which Fred Moore had taken me to the Adelaide coaling stage in late 1964. That day, she had proudly drawn the 2:15 pm to Dundalk. Now she had seen her last breath of steam.

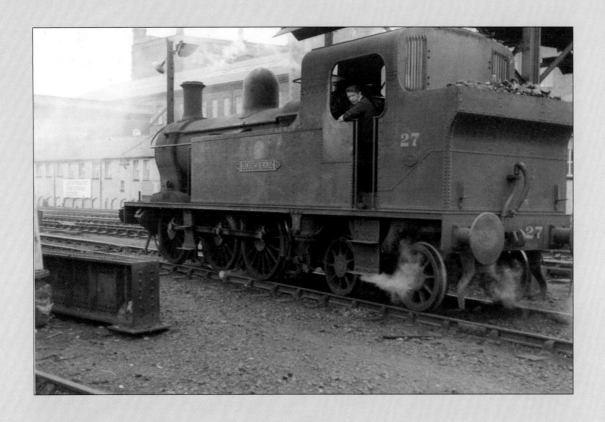

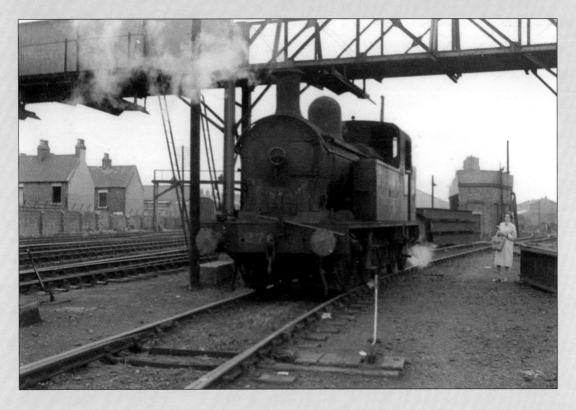

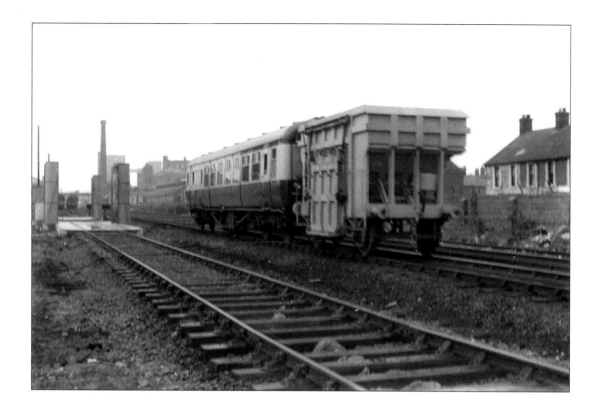

0-6-4T No 27 *Lough Erne* had suddenly arrived in view, having reversed down from the carriage sidings and is waiting for the road to proceed down to another carriage siding. The yard provided opportunities for the storage of heavy spare equipment like the bridge girders in the foreground.

In contrast to the rather austere paintwork of No 26, York Road paint shop did a lovely job of lining out No 27 after her final passage through the Works in January 1965, although here most of the finery is hidden by workaday grime. Note the shunter's pole on the bufferbeam. My mother, good Fermanagh lady as she was, reflects on the thought "Have I seen that engine somewhere before?" The bridge to Milewater Road is clearly visible.

Not the latest thing in UTA locomotive technology but one of the brand new stone wagons on test along the lough foreshore! Motive power is one of the three 61'0" long double ended MPD cars built in 1961–62. Eighty stone wagons were built for the M2 Foreshore contract, which commenced in October 1966. Initially, some trains were double-headed but after a few weeks 'topping and tailing' became the norm.

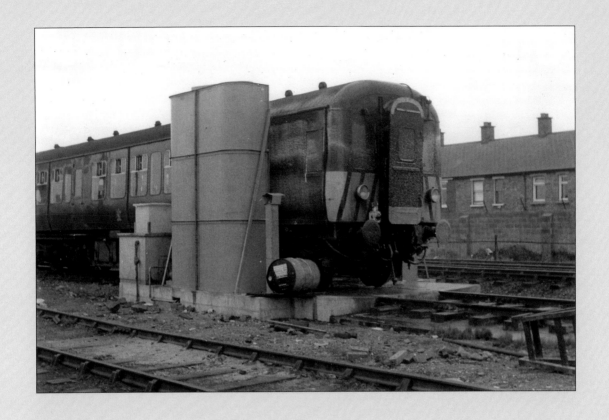

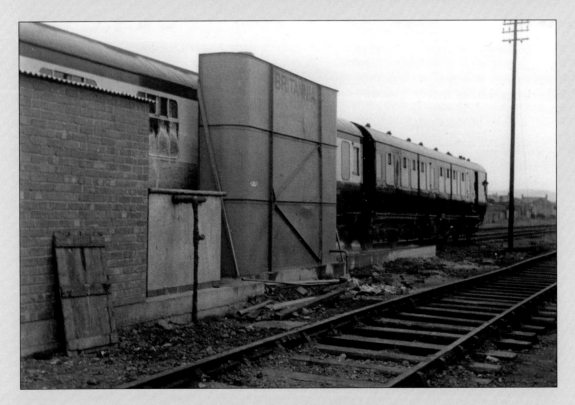

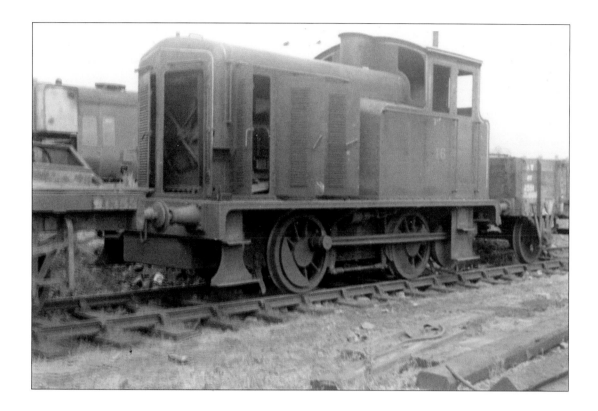

I always welcomed any opportunities to photograph something new or unusual and 11 August was no exception. York Road had a carriage washing plant on the up side of the main running lines and an MPD railcar set came to use it. The plant was in two sections and the first vehicle is being soaped. This was one of the corridor cars with high-density seating.

As the first vehicle moves clear, No 43 enters the plant. This red and cream vehicle was one of the side-corridor composites built for the Festival Express in 1951 and converted to MPD use in 1957. No doubt the brand name on the plant would have gone down well in Loyalist areas!

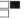

I was fortunate to find one of the three York Road Harlandic diesels that afternoon, though I was to have later opportunities with No 28 at Great Victoria Street. No 16 was originally the internal Harland and Wolff Works shunter but was hired to the NCC during the War and sold to the UTA in 1951. Neither 16 nor sister 17 ran after 1966.

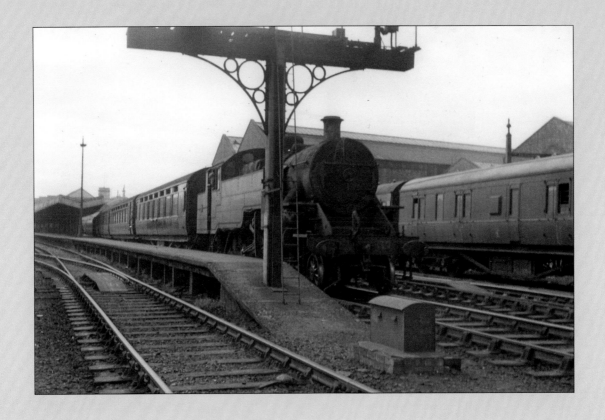

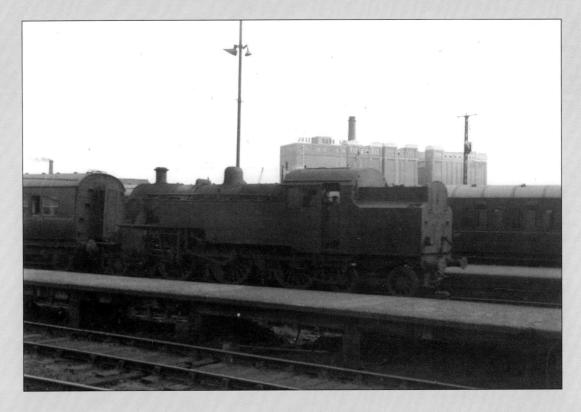

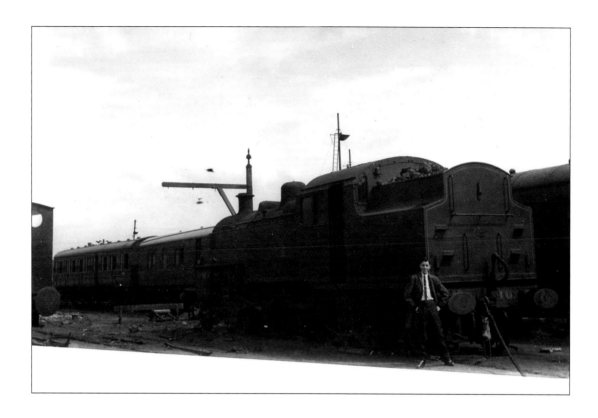

Another view of No 57 doing what she was built for, or near enough. She may well be marshalling carriages into Platform 1 for the evening Boat Train or perhaps for the approaching Saturday Specials. The leading carriages are from the lovely five-coach North Atlantic set. Harold Houston told an RPSI meeting in Belfast on one occasion that when York Road were planning to join the 'big window' era in 1934, they rang Derby to ask the width of Stanier's new windows and were told they were five feet. They were actually four feet six inches but that is how York Road ended up with the widest windows on the LMS.

2-6-4T No 6 arrives at Platform 4 with a local train from Larne Harbour. Due to the shortage of MEDs in particular, I was told that Thursday that the Larne line was 50% steam traction. Halcyon days!

I had gradually worked my way up from the Yard to the passenger station because I had heard a rumour that a newly-acquired RPSI engine, a Guinness 0-4-0ST, was there. To avoid crossing too many running lines even in those more relaxed days, I had crossed only the Platform 5 and 4 tracks, then walked up to the terminal on Platform 4/3 and sought permission to walk down Platform 1 and so reach my goal. Here, a 17 year-old author poses beside 2-6-4T No 10, with the Guinness engine to the extreme left. Note the ex-GNR K11 Third on the left and the nice ex-NCC Full Brake, also seen in the previous picture.

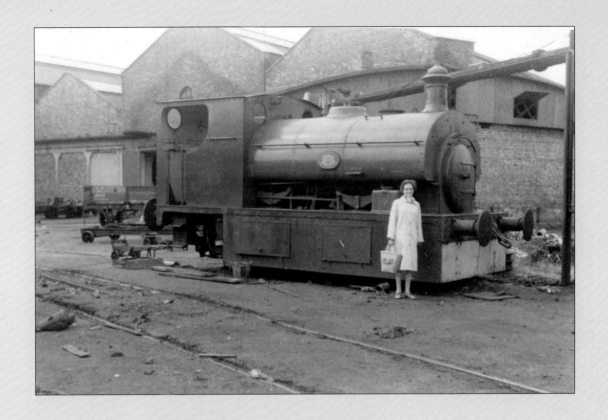

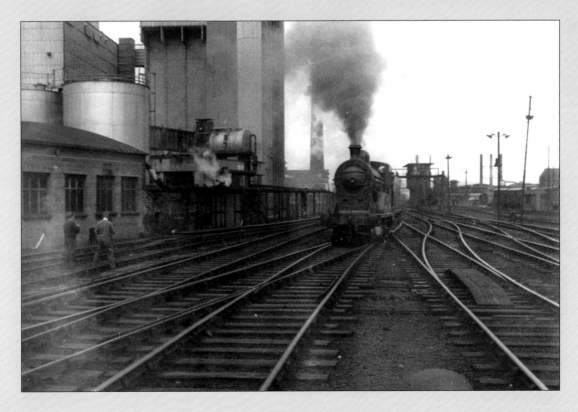

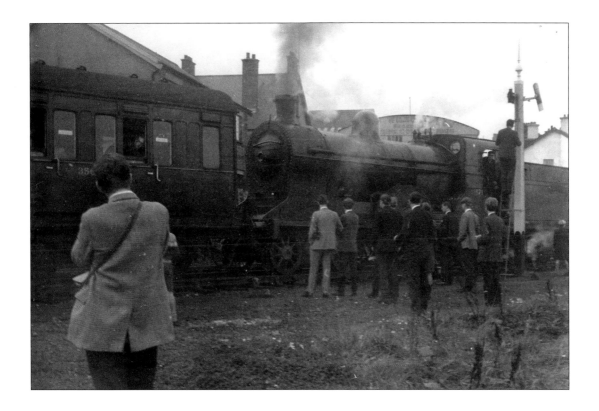

She never quite made it to being a fully-fledged member of the RPSI but my mother certainly looks the part beside the Guinness engine 3BG outside York Road Works.

RPSI S Class 4-4-0 No 171 approaches its train at Platform 2 York Road, prior to working its first railtour under RPSI custody to Larne Harbour on 8 October 1966.

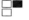

No 171 *Slieve Gullion* ventures down towards the future RPSI base at Whitehead on the same railtour, attended by a typical collection of 1960s railway enthusiasts in blazers, jackets and suits, including the late Craig Robb on the left. Will we ever see their like again?

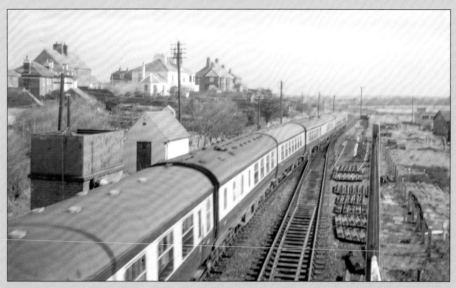

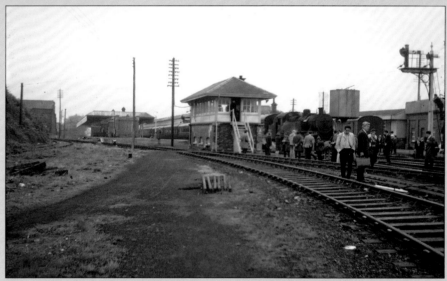

The end of 1966 was a depressing time for Great Northern area steam enthusiasts. Following the Larne Harbour Railtour on 8 October, the next development was the 'Last Steam to Dublin' on 29 October, intended to mark the last steam-hauled UTA train to Dublin, though with an exorbitant fare. A lot went but I was put off by the potentially dull weather and the feeling that the RPSI would organise further trains. The following week, Adelaide shed closed for the last time. I paid my final visit on 20 October, when I saw UG No 48, WTs Nos 51 and 54 and Compound No 85 Merlin which had been hauled to Belfast on 8 September. A few days later, Nos 48, 51 and 54–56 were taken to York Road. Merlin was placed in Lisburn Goods Shed and Nos 37 and 49 were unceremoniously dumped at the neck of Grosvenor Road Goods Yard. Apart from two RPSI tours, there would not be a puff of steam on the Great Northern for the whole of 1967. The only steam would be on the NCC. At the start of 1967, it was announced that the red and white NCC section livery would be standardised over the whole network. To some extent, this was predicated to the fact that Werner Heubeck, the dynamic new Head of Ulsterbus had already selected blue and cream as his corporate image. He would have been anxious to distinguish his vehicles from the Corporation's. The railways may have felt that they needed to go for a variation on red to avoid confusion. There was even a rumour for a few weeks that the railways would be called UlsterRail rather than Northern Ireland Railways, since road freight was Northern Ireland Carriers. The first train to be repainted in the new colours was the BUT Enterprise, albeit with hand-painted decals. The Down Region adopted the new scheme with enthusiasm. Their colours had been too like the old UTA scheme.

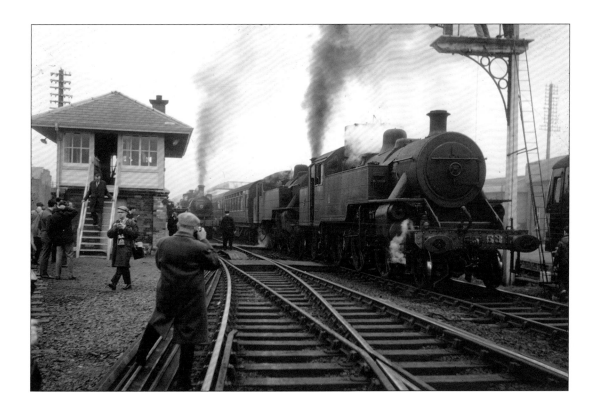

I was in Castlerock again early in 1967, during a bitterly cold Easter. This view on Easter Monday, 27 March 1967, is at the Coleraine end of the station and was my first colour shot of a 70 Class train. Due to expected heavy traffic, it is an eight-car set with three power cars. An obvious snag with this arrangement was that a continuous corridor was not possible.

In the first half of 1967 I was busy studying for my A-Levels but nevertheless took Saturday 13 May off to go on the Dalriada Railtour to Portrush, the first tour to use our recently acquired J15 Class 0-6-0 No 186. An unexpected pleasure on this trip was the presence of John Coulthard, the boss of the railways. He clearly intended to revive the railways but that morning he had been dismissed from his post. We treated him as something of a hero that day. The train was hauled to Ballymena by 2-6-4T No 55 and this view was taken just after the Special reached there. At this time, Ballymena had not changed since the early 1960s so we can see the former narrow gauge platforms on the left. The engine shed and yard are behind me.

After a few minutes No 186 joined the head of the train, creating a double-header. There was then a short delay to allow another passenger special for Portrush to overtake us. This also turned out to be a double-header as the train engine, No 10, was piloted by No 53. Apparently, an MPD set hauling a goods train to Derry had failed and No 53 was to come off at Coleraine to substitute. As can be seen from the excitement, I was not the only enthusiast to sense a photo opportunity!

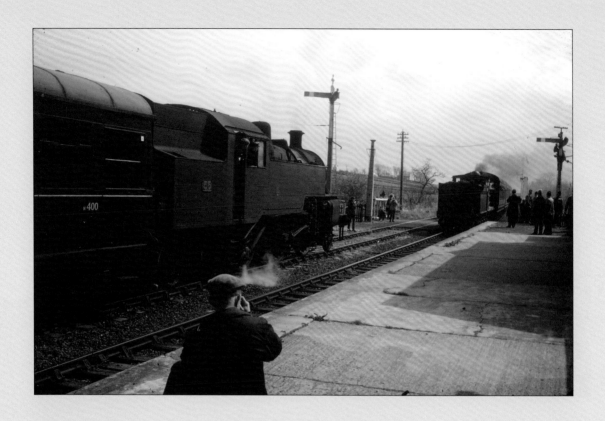

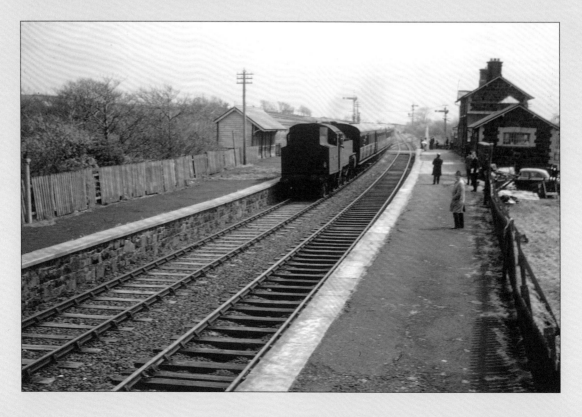

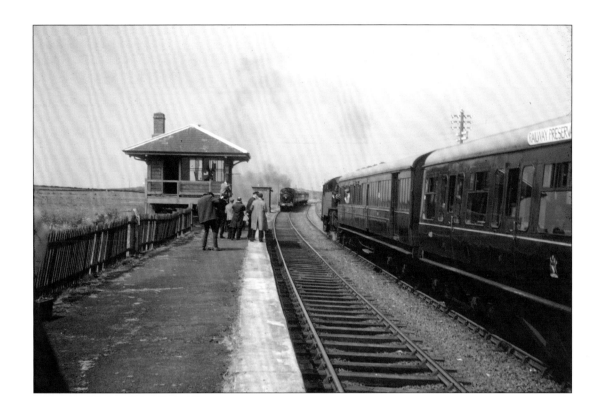

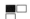

For me the most pleasant part of the whole Dalriada experience was the afternoon spent at Portstewart station. Having the long passing loops at Portstewart made the whole idea of crossing trains there viable. Here at 2:05 pm, No 55 waits at the up platform for the arrival of No 186 on the 1:55 pm from Coleraine. The leading coach on 55's train is N400, one of the original 1935 batch of GNR K15 Thirds with square-edged windows.

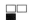

About half an hour later, it is the turn of No 55 to arrive from Coleraine, this time viewed from the cabin. Each train used on the branch was four coach. We also see Portstewart's lovely stone station building.

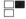

The leading coach on No 55's train is nicely-panelled L9 Class Brake Third No N466, typical of 1920s GNR stock. Meanwhile, a chimney-first No 186 approaches the signal cabin.

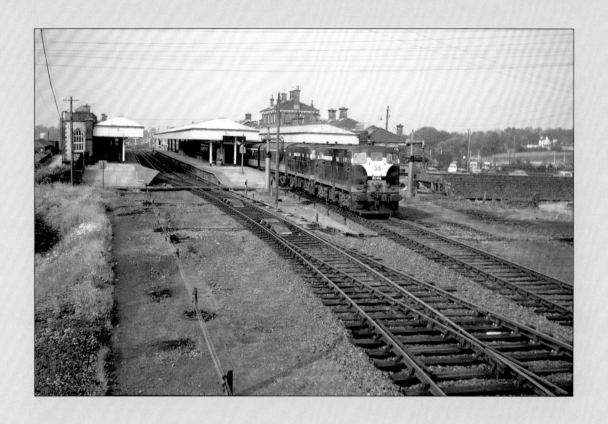

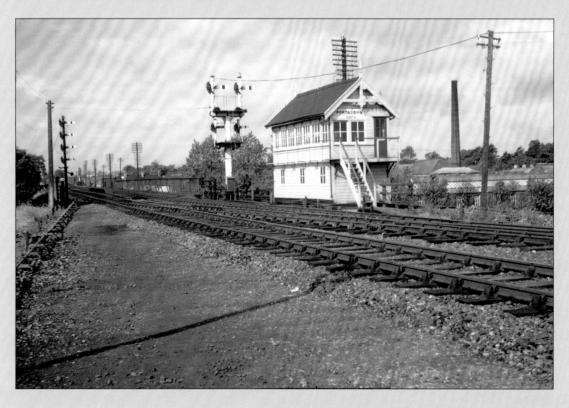

Back to Portadown, A-Levels were in full swing in June but on Saturday 17th, I took an evening break from revision to photograph B146/B145 on the 5:30 pm Belfast to Dublin. This was my first slide from the South Cabin, which had closed a short time earlier when the southern approaches to Portadown were simplified. The loops for Platforms 1 and 4 have been shortened and the Bann siding removed. The signal wires and rodding are now worked from the former North Cabin.

From this point until the 1970 station was built, the South Cabin was to be one of my favourite vantage points for photography. My A-Levels finished on 20 June and next morning I went to the station for a photo shoot. The trackbed of the Bann siding is in the foreground. Thankfully, the attractive semaphores beside the Bann Bridge remained in use. The four smaller signals on the left control access from the goods yard to the various platforms. The nice bracket signals are the home signals from the down line to Platforms 3 and 4 and there are also calling on signals for shunting movements within the station.

All the above movements were controlled from the North Cabin after 1967, now neatly enlarged with extra levers and renamed simply 'Portadown' (compare before alteration on page 11). In contrast to the south end, there were minimal alterations at the north end after 1967. By now, clerestory bogie brake van No N609 has appeared in the siding at the end of Platform 4. This van served as an office to process racing pigeon traffic, then very commonly consigned by rail. N609 was former GNR M1 van No 464 which had been in the GNR World War One Ambulance Train as Ward C. The tank wagon used for signal lamp oil is attached to No 609 and is just visible through the steps of the cabin.

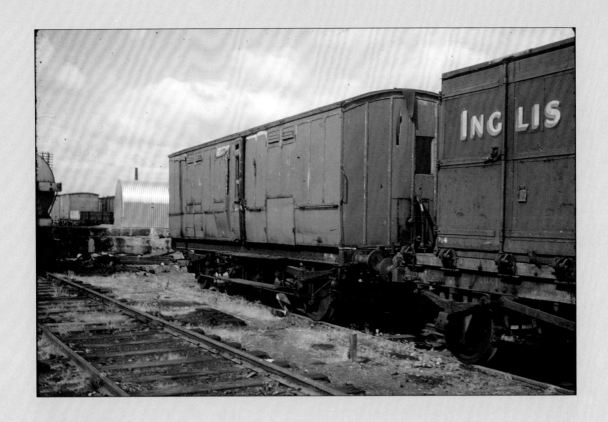

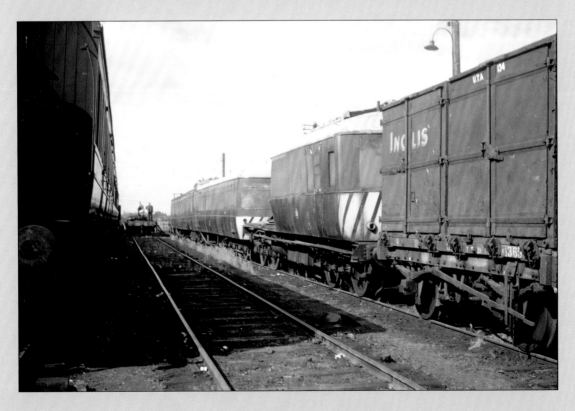

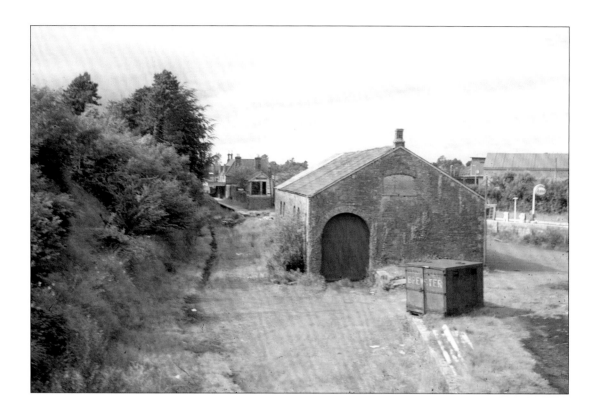

It was a rare thing in 1967 to see a genuine ex-LNWR six-wheeled brake van but life can throw up the unusual. This one had been part of the stock of the Dundalk, Newry and Greenore Railway (DNGR) and, after being taken over by the GNR in 1951, this example had served as stores van at Enniskillen shed for many years. Even the closure of Enniskillen in 1957 didn't threaten the van since it then had the same role at Portadown shed until the start of 1965 (see page 18). Now in 1967 it really was under threat.

Further into the carriage sidings I found two of the former GNR Gardner diesel railcars. The nearer was the pioneer Railcar A, built in 1932, though originally AEC-engined. It had been UTA No 101 but had been involved in a collision at Derry. This did not prevent it being used as a platform for a mobile winch during the lifting of the Derry Road in 1966–67. The articulated railcar beyond is UTA 104 (GNR F of 1938) also used on the lifting train but in this case to transport workers to and from the retreating

railhead. Both railcars were in storage in this view but saw similar use down south on other lifting contracts.

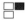

While on a Fermanagh theme, this was my normal destination station of Lisnaskea, when I travelled regularly to God's own county. It is seen here in 1967 a year before the distant buildings were demolished to make way for a housing estate. The goods shed in the foreground was taken over by Meliffe's filling station and still exists. The side next the road is now rendered but the wall facing the hedge is still stone finished. Note that all three pictures in this spread include former bread containers although bread no longer went by rail in Northern Ireland in 1967. Inglis was a Belfast bakery whereas Brewster were based in Londonderry.

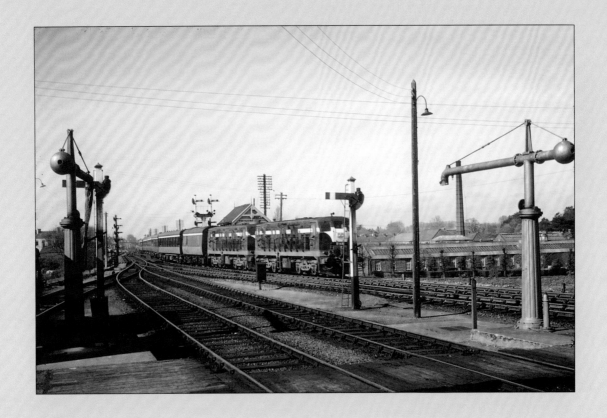

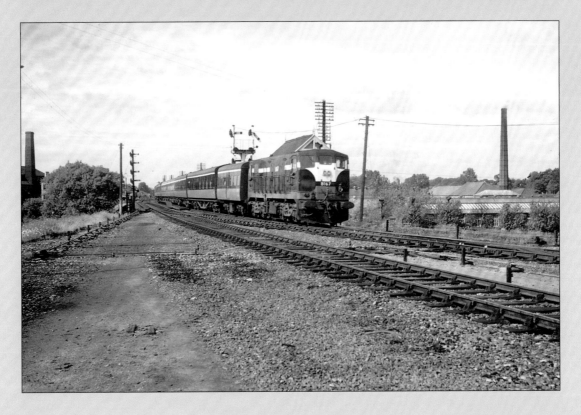

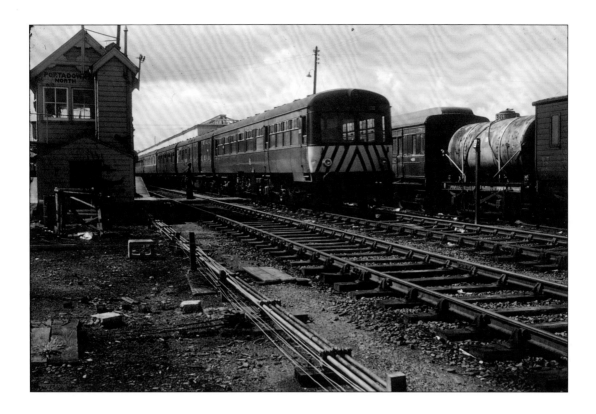

Comparison between these two views illustrates well the changes made in 1967. The first was taken on 30 April 1966 and shows B168/B141 arriving with the 8:30 am Dublin–Belfast Enterprise. The second shows B167 on the rather shorter 11:00 am, comprising five coaches spliced between four-wheel heating and luggage vans. Two of the carriages are 1964 Cravens and the rest 'laminates'. The considerable reduction in trackwork is clearly visible. The shortening of Platforms 1 and 4 required short additions to be made to the platform facings to bridge the gaps between the curves and the carriage doors.

On 19 August 1967, a five car BUT set does a shunt at Platform 4. At this stage the Enterprise was still the only BUT set in NIR livery and 555 was the only red and white AEC-fitted carriage. This set comprises 135-L14-584-128-125, all in UTA green, apart from 128 still in regional blue. Note W1 six-wheel van No 601 on the extreme right.

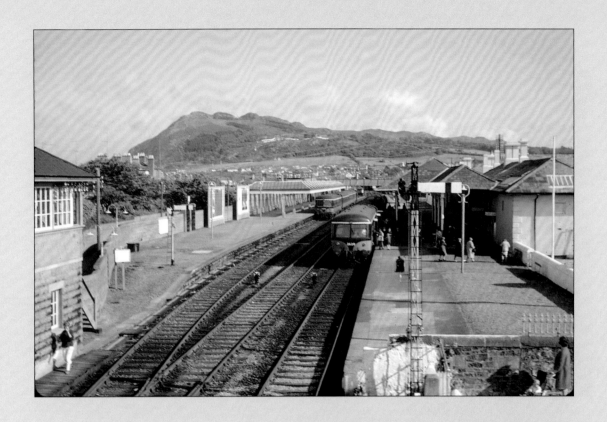

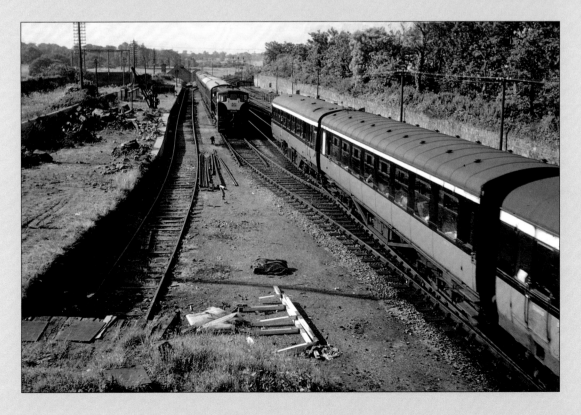

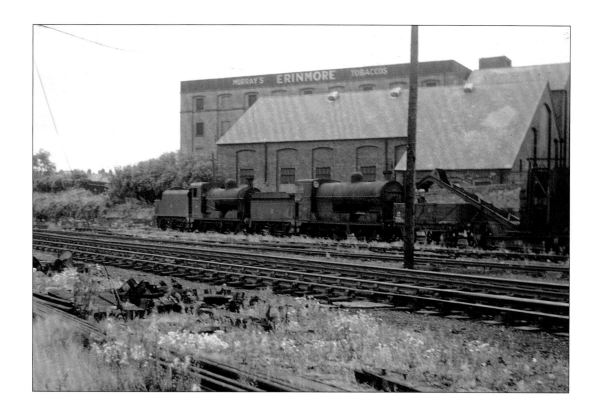

The Portadown Baptists were well known for organising interesting annual excursions and excelled themselves on 24 June 1967 when they hired an eleven coach CIÉ train to take them to Bray, hauled by two GM B171 Class locomotives. In addition the Lurgan Baptists fielded a six coach UTA set hauled by smaller B164. The Baptists were good at marketing their trains to others in the town so I went myself along with three friends (only one of them a Baptist!). I well remember us being welcomed at Bray by a Fianna Fail loud speaker van, emphasising the significance for good north-south relations. At this time, the Dublin suburban services were very much a railcar operation and two sets are visible here at Bray. These were very comfortable trains, far superior to the dreadful push-pull sets they were converted into in the late 1970s with hard plastic seats. The later DART trains of course had much superior acceleration.

The set seen loading at the up platform in the previous shot now departs for Dublin, passing as

it does B164 with the Lurgan excursion, stabled at the loading dock. The CIÉ livery introduced at the end of 1961 was designed by the artist Patrick Scott (1921–2014) who was apparently inspired by his favourite cat *Miss Mouse*, who was orange, black and white. Although often described as 'black and tan', the official colours were "black and dipped golden brown". The black band was very successful at disguising different window heights.

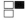

On Saturday 19 August 1967 my parents and I headed off to Portrush for a week's holiday travelling to Great Victoria Street in the BUT set seen two pages back. As I was determined to photograph the two GNR 0-6-0s stored at Grosvenor Road, I had already worked out that if I walked past the Ulsterbus depot to the carriage sidings I could walk from there to Grosvenor Road yard without crossing any dangerous running lines. So I did precisely that and this is the result. UG No 49 is on the left and SG3 No 37 on the right. Note the hand crane on the right.

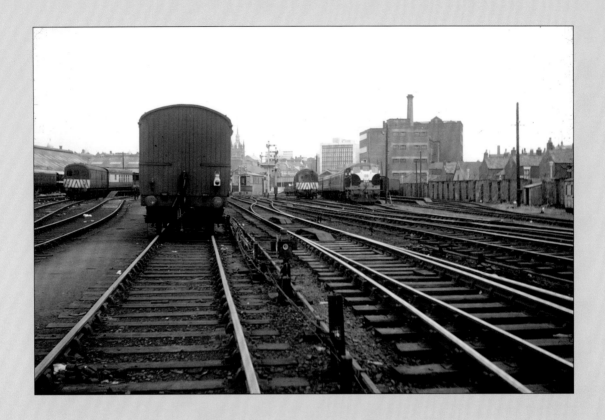

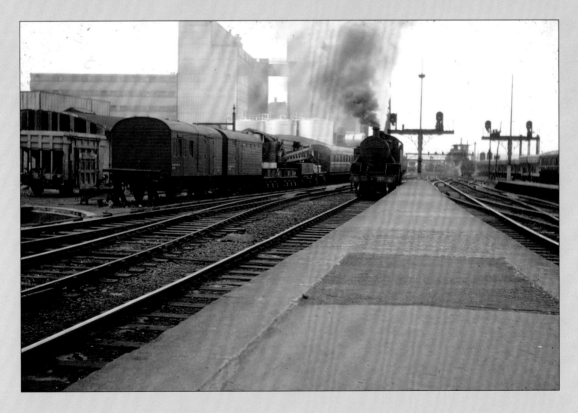

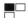

On my way back up to the station, I took this view as I walked through the down side carriage sidings. At this time a number of non-corridor MPD units were allocated to Great Victoria Street for track maintenance duties and two such are visible. CIÉ B184 is in the up side carriage sidings after working a shopper's trip from Dublin. Directly in front of the camera is a Y6 four-wheel van, whilst in the middle distance is B8 buffet car No 551, the spare Enterprise catering car. Just visible to the left of the nearest MPD car is Inspection Saloon 150, recently repainted in a unique purple livery with yellow band.

From Great Victoria Street we took a Corporation bus to York Road and joined the 3:05 pm to Portrush. Whether by accident or design, I was delighted to find this was a booked steam train, the only one to Portrush on summer Saturdays. It was a seven coach set and started from Platform 2. Predictably the '3:05 Club' of timers were in the leading coach (350). No 55 arrives to take up its train with other engines visible up the yard. In the background, the NCC large breakdown crane has just been repainted into NIR dark red livery and is stored beside the Platform 1 road. It includes two stores vans converted from NCC 'brown vans' with a GNR K13 side-corridor Third in use as staff accommodation. The crane is steam operated. Now retired, this breakdown train is now on display at the Downpatrick and County Down Railway.

By and large, I avoid using 'out of the window' shots in books but I make an exception here. I knew we would be meeting the 12:45 pm Derry–Belfast, the only other 'booked steam' working on the Saturday summer timetable, and wanted the two trains crossing. They met near King's Moss No 1 level crossing and the 12:45 pm was in the charge of No 5. It is amazing to look at the quality of the NCC track bed at this time (it was still double track all the way to Ballymena in 1967). I had to get my shoulders in quickly after pressing the shutter as the closing speed of the two trains was not far short of 120 mph!

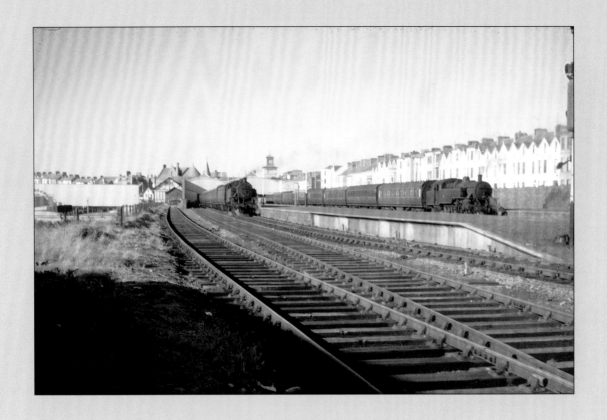

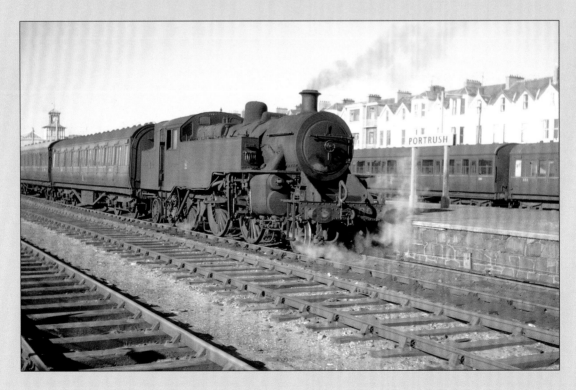

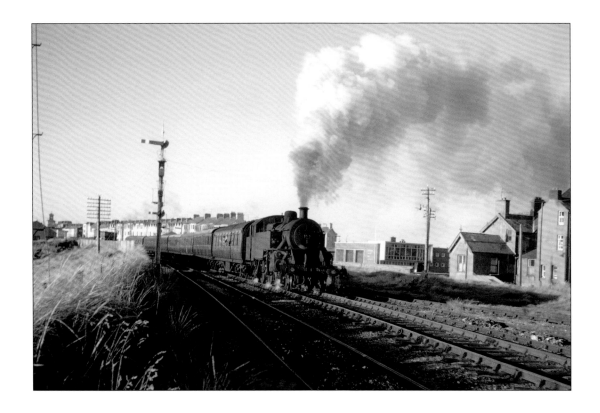

After arrival at Portrush, we booked into our guest house and I came down to the station after the evening meal to observe the departures south. Two trains were scheduled. Our train was at Platform 3 and Platform 1 had the return working of a Cullybackey Sunday School outing, in the charge of No 10.

A nice portrait of No 55 waiting at Platform 3 with the 7:30 pm to York Road. Both trains were a mix of GNR and NCC bogie carriages, the one behind the running-in board on the Cullybackey train being a nice example of a 1933 GNR K13 Third. The first carriage on the 7:30 pm is NCC J6 side-corridor Third No 256.

2-6-4T No 55 departs on schedule with the 7:30 pm on a lovely August summer's evening. The red brick building is Portrush Fire Station, then new. In the right background, the track leading to the disused turntable can be discerned. Sand always made this a difficult table to maintain.

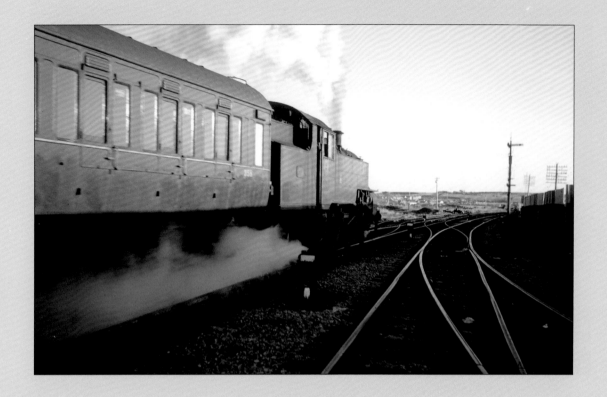

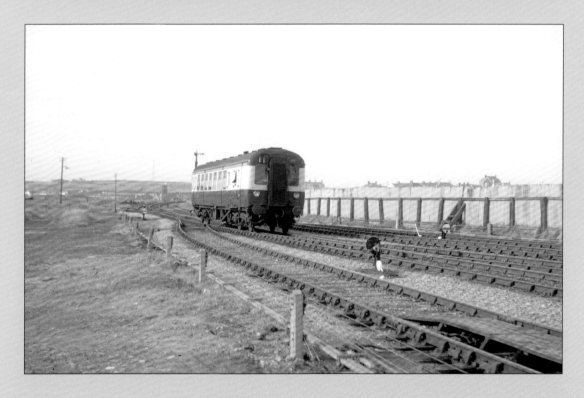

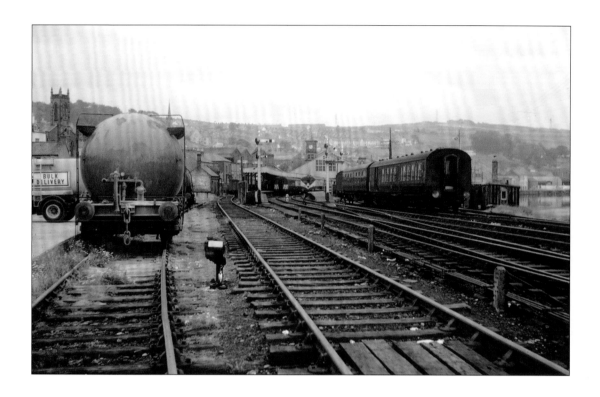

At 7:45 pm, No 10 departed with the Cullybackey special with coach 358 (another J6) leading. The Christian Endeavour home, Castle Erin, is just out of sight to the right and the track trailing off to the right led to the old harbour branch.

On Monday 21 August we see MPD railcar No 63 arriving at Portrush on the 12:05 from Coleraine. This was the normal formation for branch workings in the period 1965–67. In the early 1960s it would have been ex-NCC railcars 1 or 4, dating from the 1930s. From about 1960 until the opening of the New University of Ulster in 1968, the branch was only open in the summer. That all changed with the University, as students made use of the readily available accommodation in Coleraine and Portrush and needed daily transport to the new railway halt. Dhu Varren also reopened.

Londonderry, Waterside, on 24 August 1967 with a mixture of trains in view. There was still a healthy traffic of two goods trains daily, bulk cement being a predominant traffic, as seen here. CIÉ lorries forwarded the unloaded goods to Letterkenny and other places in Donegal. The distant 70 Class set comprises 74-702-548-723-71-617 (the latter a brake bogie van) and had worked the 8:35 am from Belfast (our train). It is preparing to return on the 11:15 am. There is a two-car MPD on the right and another MPD in the distance at Platform 2.

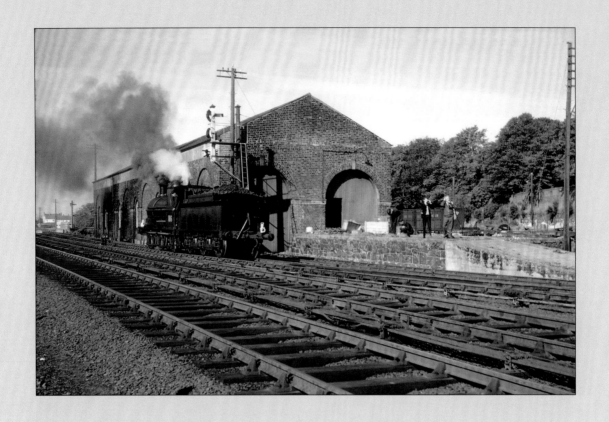

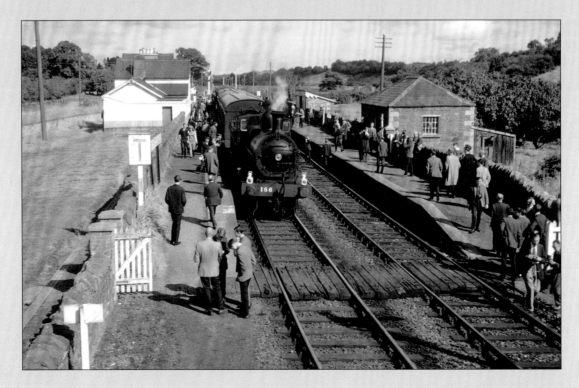

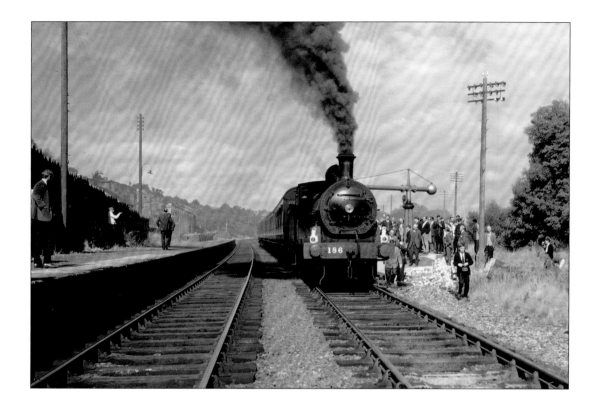

The Autumn brought two more RPSI railtours, both hauled by 186, as No 171 was no longer serviceable and awaiting funding for a full overhaul. The Cuchulainn Railtour was on Saturday 9 September and went from York Road, via Antrim, to Dundalk. One enthusiast gloomily predicted that if 186 broke down south of the border, CIÉ would cut her up on the spot! Here, after running round at Lisburn, Driver Billy Croft reverses No 186 back to Platform 3 to pick up her train.

The sun shone on us for this trip. The train is seen here at the Poyntzpass stop, where it crossed both up and down Enterprises. First came the down CIÉ Enterprise just after we arrived and we have just switched to the down line ourselves to clear a path for the up train.

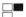

Goraghwood was a bit of a shock for those who had not seen it since the Warrenpoint branch closed at the start of 1965. We had arranged to take water here, this involving special arrangements by my friends Johnny and Will Glendinning, John Friel and Aldo Magliocco. While taking water, No 186 shovelled on coal in readiness for the climb up to the top of the bank beyond Cloghogue Chapel. My late father, George Johnston, can be seen in brown flannels and grey jacket with his back to the water crane. At least in 1967 the platforms were still there. Within a few years even they were gone.

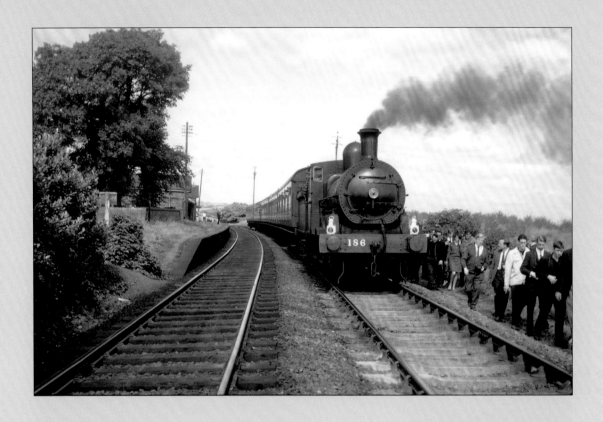

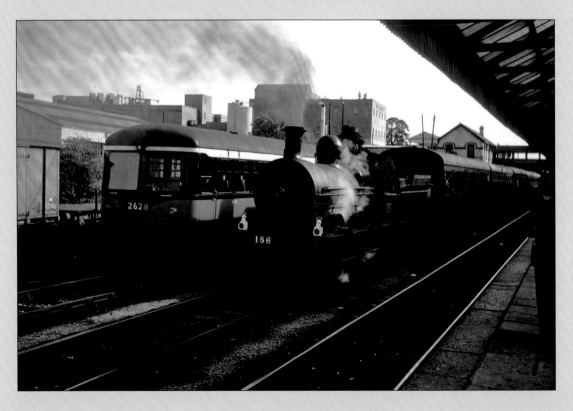

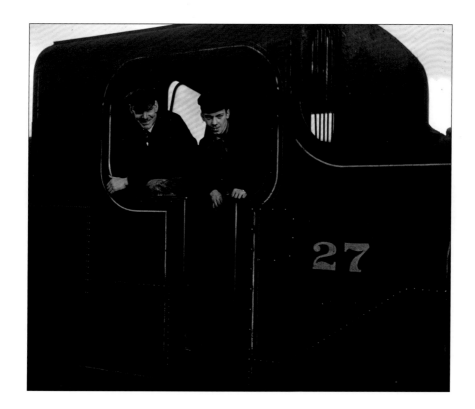

Another interesting stop, with the future in mind, was Bessbrook station. The more astute reader will recognise this as the future Newry station, substantially rebuilt in the 1980s. Today, it is a very much bigger station than it ever was in the 1960s. Amazingly, in 1965 it did not occur to the railway authorities to provide an alternative to Edward Street station when the Warrenpoint branch closed.

Despite the gloomy forecast, No 186 did not break down at Dundalk or get cut up! She even traversed the Barrack Street branch and is seen here back at Dundalk station, alongside an AEC railcar, ready for the return to Belfast.

The Killultagh Railtour was on Saturday 28 October and ran from York Road to Great Victoria Street and back. Motive power was a combination of 186 and No 27 *Lough Erne*. Here the crew of No 186 pose at Doagh on the way to Antrim. The driver, on the left, is Rab Graham and his fireman is Albert Plews.

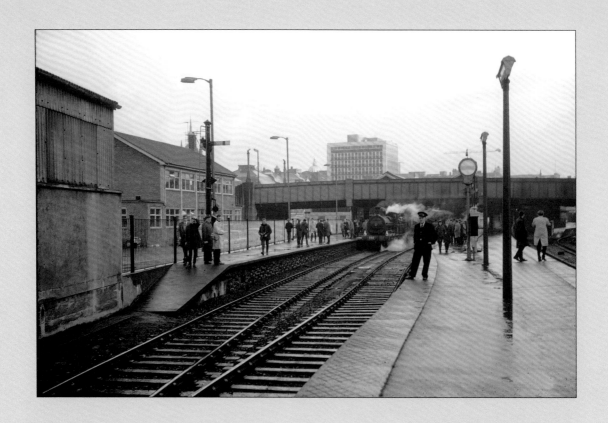

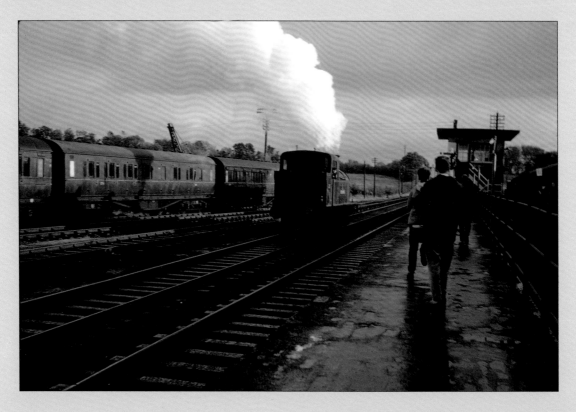

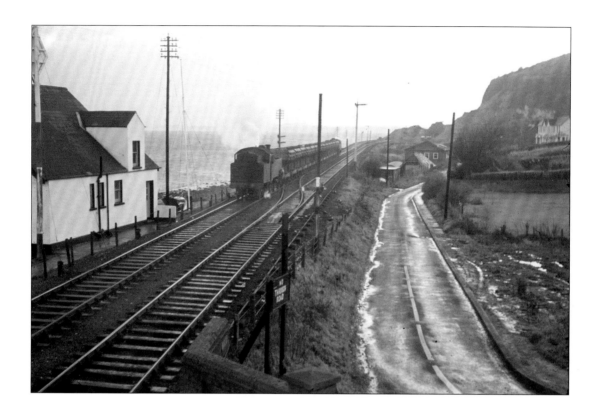

Great Victoria Street around lunchtime, with 186 at Platform 4. We had left No 27 at Antrim. The gentleman in traditional UTA uniform lends atmosphere to the platform scene.

Back at Antrim, No 27 had steam raised in readiness for the double-header back to Belfast. The afternoon had been showery but the sun has come out. In 1967 a lot of carriages were stored at Antrim over the winter. The GNR sidings to the right are full of them.

In late 1967, NIR introduced a special return fare from Belfast to Whitehead to make it cheaper to travel to and from the new RPSI base. Provided you had your RPSI membership card with you, you got the concession. I must confess that my friend John Friel and I cheated slightly by using the tickets to travel to Whitehead to photograph stone trains! The first occasion was on Wednesday 15 November 1967 when this picture of a receding train heading for the tunnel was taken. The engines are Nos 5 and 6. Although we took it for granted in 1967, it was double track all the way from Carrickfergus to Whitehead at that time.

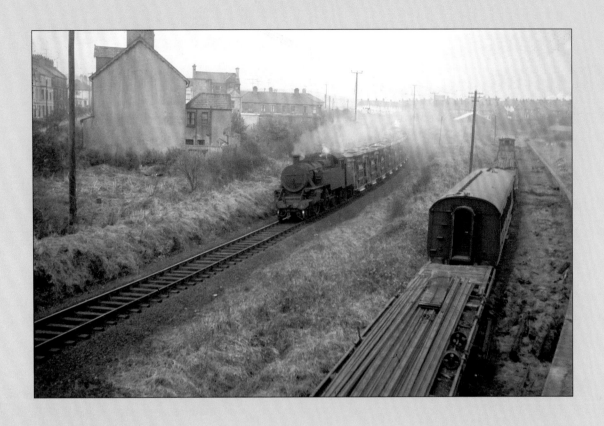

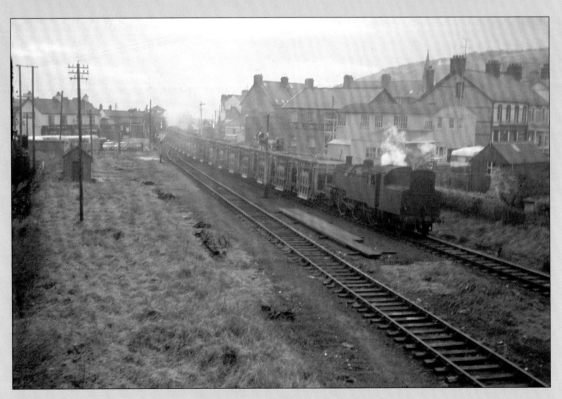

1968

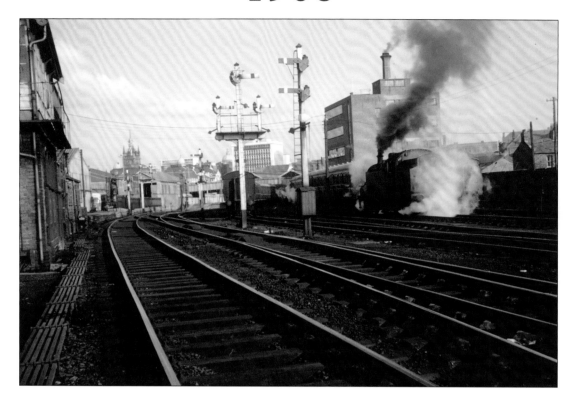

About a month later, on Wednesday 13 December, Kings Road bridge provides a useful vantage point for a picture of Nos 51 and 53 on an up stone train, passing Whitehead Excursion Station. The RPSI base is host to an NIR Works train, consisting of several bogie flats of rails and an accompanying mess coach. Today, this scene is utterly transformed by RPSI activity.

A running away shot of the same formation heading towards the main Whitehead station and about to pass what was then the Bus Depot. Commonly, stone locomotives worked chimney first towards Belfast.

"Big engine up the yard…" Early in 1968, I decided to start making regular trips down to the Great Victoria Street sidings to check out what was going on. The first occasion was on Wednesday 14 February and as I passed Platform 4 I saw my friend, Joe Cassells, looking animated. When I asked what was up, he said "Big engine up the yard." Sure enough, 2-6-4T No 3 was in the up side passenger sidings attached to a train of bogies. Apparently, there were Rugby Internationals in Dublin the following Saturday and No 3 was there to use its steam heating to thaw out the coaches of the Specials after the winter.

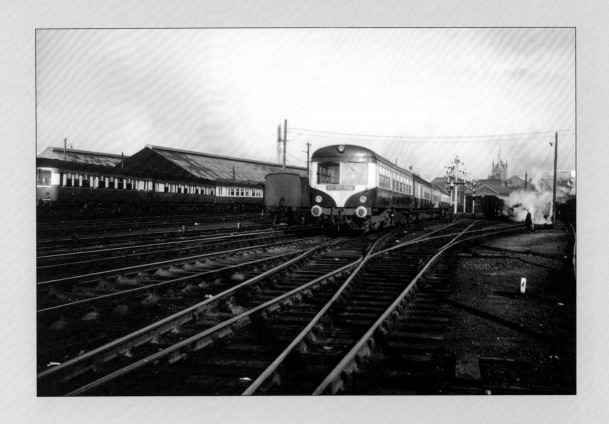

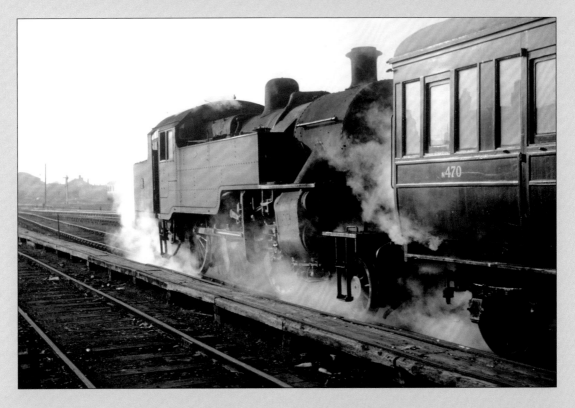

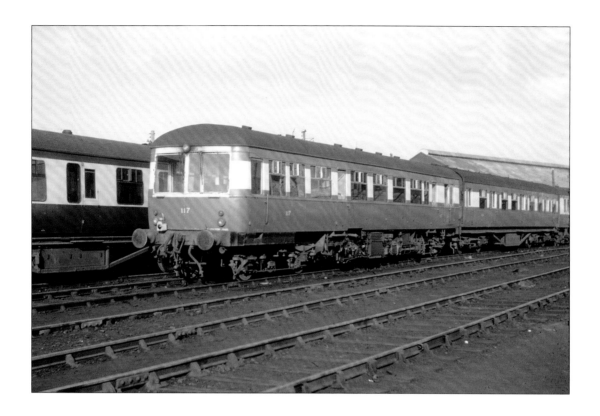

This second view is taken from the carriage sidings and shows the 2:30 pm Enterprise departing past No 3. On a mid-winter's weekday this train was often only a four-car set, the formation consisting of 133-562-552 and a 121 Class car. Over on the left we see AEC set 117-583-118 all neatly in the 1965–66 blue and cream livery.

This shot is taken from the carriage sidings and I liked the lighting effect. No 3 was probably chosen for this duty because her frames were giving problems at this time and she was less fit for stone train duty. The carriage is an L10 Brake Third dating from 1929, built for excursion duties where her single small guard's van (at the other end) meant an eight-coach train could have a van at both ends without a cost to accommodation. Between each siding here was a wooden platform with narrow gauge rails, used in GNR days by carriage cleaners for their soapy water.

A big part of my interest in Great Victoria Street in 1968–69 was to record the various vehicle types used as railcar trailers and the different liveries they wore. This in turn led to keeping records of ordinary hauled carriages, both facilitated by the cast plaques carried high on one end of each carriage giving class, width, length and weight. I include a selection of these on the next few pages. On the left in this shot is MPD driving trailer 533 in the pre-1967 version of the red and cream livery. Then we have an AEC set in blue and cream. As K31 586 was the only blue trailer, only one such combination was possible. Note the narrower cream band on 117 and 586, compared to 118. This was intended to distinguish 'suburban' use stock but was abandoned in mid-1966 as an unnecessary complication.

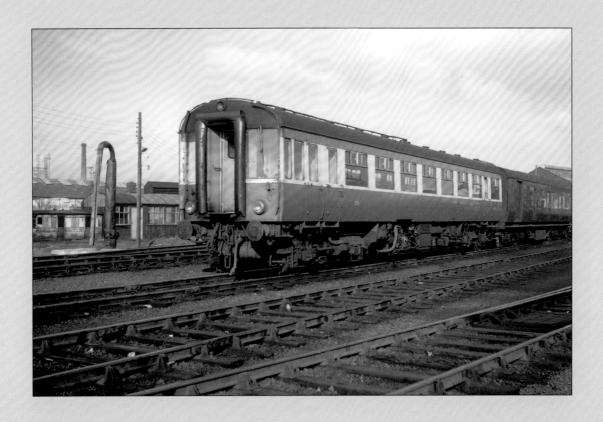

BUT railcars always had the deeper 'main line' cream band of course. No 128 is coupled to one of the two green L14 Brake Thirds (594/5) and to probably 131 or 134 in NIR livery.

At the inner end of the down carriage sidings, a non-corridor MPD railcar provides the background to a portrait of K23 Third No 556. In the early 1960s this had been a small Derry Road Buffet Car, used with BUT railcars. In 1965 the bar/buffet had been removed and replaced by large picture windows taken from K15 Third No N416, increasing seating capacity from 48 to 72. As No 556 had 48 tabled seats, it was now ideal for supplementing Diner 552 on the Enterprise. In 1969, after a 70 Class set was allocated to the Enterprise, this car was recabled for the new train and renumbered 727. This made it eventually the last ex-GNR vehicle to remain in daily service.

Alongside that afternoon was a rake of BUT vehicles, mostly in blue and cream. Nearest the camera is one of the two L12 Brake Thirds, either 591 or 592, followed by double-ended power car 123 and another in the same series.

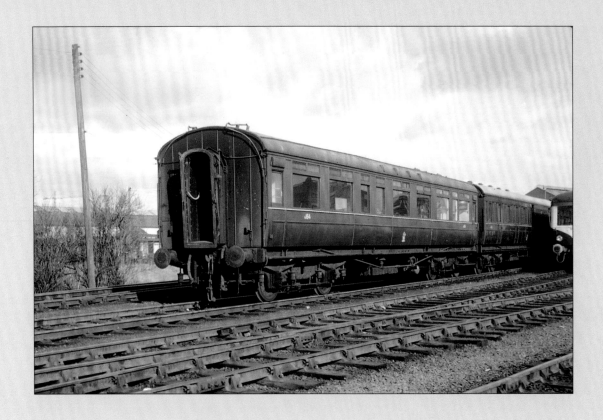

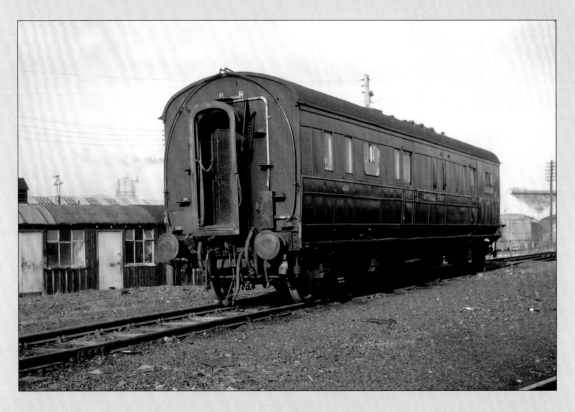

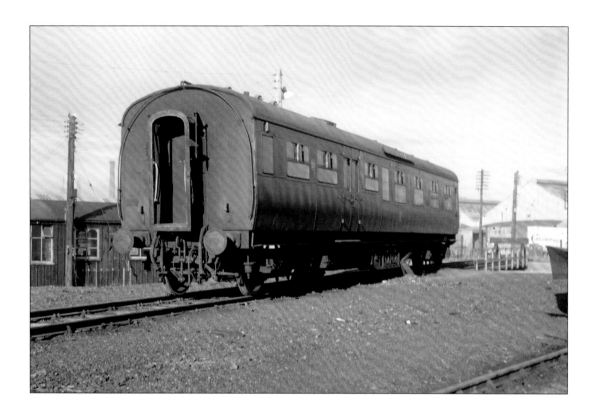

We now look at some of the UTA/NIR catering vehicles still in stock in 1968. Hauled cars were Nos 162/4/6 (even numbers indicating corridor vehicles), and railcar-fitted Nos 548–554 (the first three ex-NCC). This lovely centre kitchen Dining Car is GNR B1 No N164 and was built in 1925, to replace a similar 1916 car that had been destroyed at the Dromiskin collision in 1922. It was a composite seating 18/23, had been GNR No 402 and was withdrawn in 1970. One of its lovely features was the etched glass in the two toilets (far side) depicting the GNR coat of arms.

Kitchen Cars were very rare in Ireland but the GNR had two. A Kitchen Car has no passenger seats, with the entire interior given over to cooking and serving. The GNR cars dated from 1940 and were conversions from narrow low-elliptical roofed M2 full brakes built in 1901-02. No 166 had been GNR No 399 (1901) and was only 48 feet long. She was a vital part of the International Rugby season and was used for the 'All in' trains, where the ticket covered match, train and main meal. She had other uses too and had been cabled to running with AEC railcars. The siding she is in had a turntable (far end) and was used a lot for catering vehicles.

At the same location, but an earlier date, is much more modern end-kitchen B4 Dining Car No 554, one of the last two GNR catering vehicles, built in 1954, and therefore only 13 years old here. As the reflected light suggests, the panelling is hardboard, rather than steel, because of post-war metal shortages. She too was AEC-fitted which had made her ideal for the 12 noon steam train to Dublin in the early 1960s. A B10 Buffet Car had also dated from 1951 but passed to CIÉ in 1958, though it was common on trains to Belfast in the late 1960s. The turntable beyond had come from Ballymena and was installed here when the UTA had plans to replace Adelaide locomotive shed with a few locomotives based here. The plan came to nothing. The turntable was later extended by the RPSI and installed at Coleraine for Portrush Flyer locomotives.

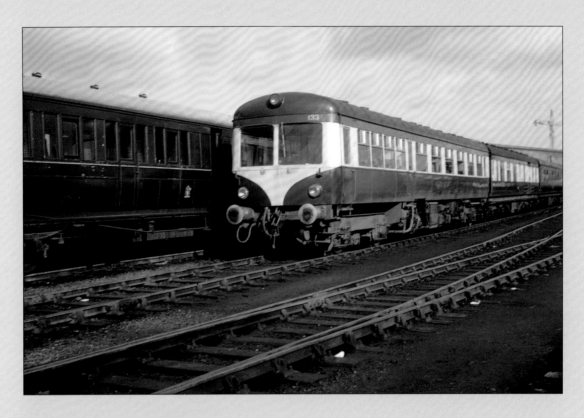

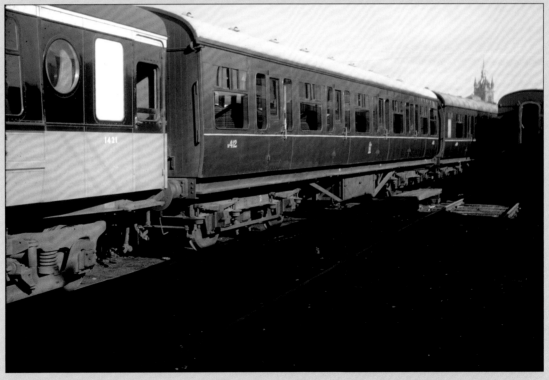

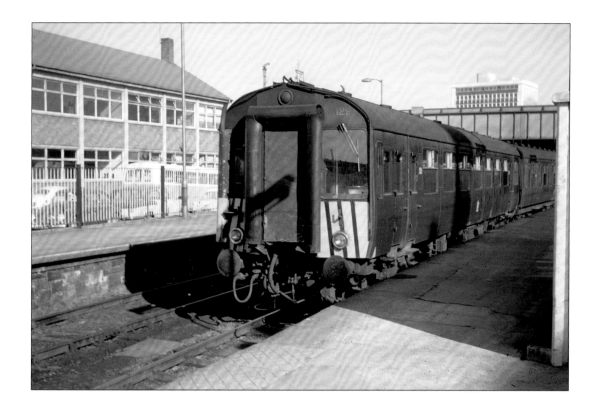

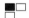

Many enthusiasts only started recording the AECs and MPD when they were very run down and faded so I was glad that I started my record in 1968–69 when they were emerging from Great Victoria Street Railcar Shops on repaint. This group of vehicles shows a 1931 L9 Brake Third, No N466 on the left and a mainly fresh BUT set comprising cars 133 (Compo), 572 (F16 Brake Compo) and what I think was K15 Third No 584.

Most hauled stock in Belfast was stored in the sidings on the up side, which was also used for CIÉ stock up from Dublin. Buffered against Park Royal second class open No 1421, we have at least two ex-GNR K15 Thirds, the nearest of which is N412, one of the Wartime batch with rounded window corners, converted from K23 Utility coaches.

A unique vehicle in the BUT railcar fleet was Car 129 (GNR 715) which had been destroyed by an engine fire in 1962 and then given a new body, comprising MPD window frames and other non-GNR features. It is seen here at Platform 3, Great Victoria Street about to set out on a run to Portadown. It was to retain its 1962 green livery until repainted into NIR railcar livery in 1969.

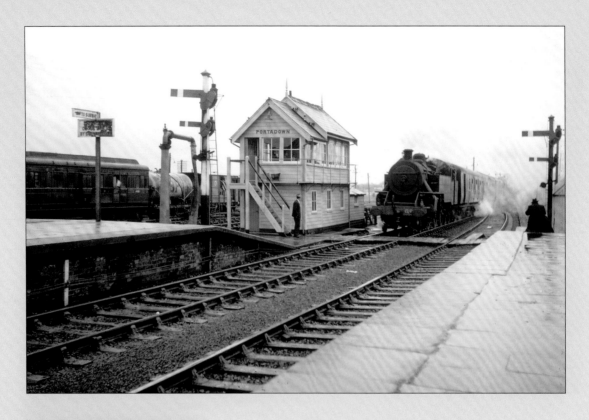

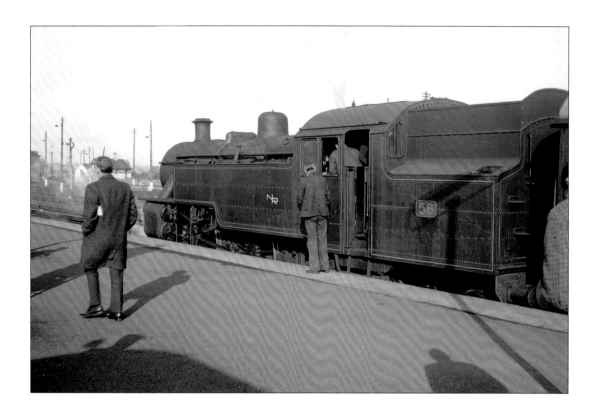

On 4 May 1968, the RPSI organised the Slieve Cualann Railtour to Wicklow, the Tour commencing at Great Victoria Street to save time. No 186 went to Dublin ahead of the Tour, which was hauled by WT Class 2-6-4T No 56, one of the best of the class. Although the morning was wet, the weather picked up in the course of the day. Here No 56 arrives at Portadown's Platform 2 in time-honoured fashion, while a 'well-happed' photographer records the scene (we hope!).

Dundalk proved a useful watering stop as is the case with most RPSI specials to Dublin. There is now a large car park where I am standing. This full broadside view gob-smacked some members of the Modern Railway Society of Ireland when I first showed this view at a slide show in the 1990s. Some of them could not get their heads round the idea of a steam locomotive carrying the NIR logo! But No 56 was by no means the only Jeep to carry this feature.

The evening trip back from Connolly to Belfast was memorable for the speeds we attained, even somewhat controversial at the time! The crew treated the run as a 'Last Fling' on the GNR main line and gave it everything they had. Long stretches between 80 and 85 mph north of Drogheda led to a 20 minutes early arrival at Dundalk. It was certainly the fastest run I ever did in a steam train.

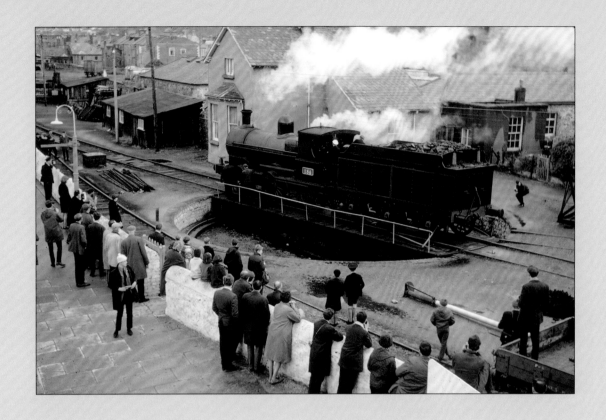

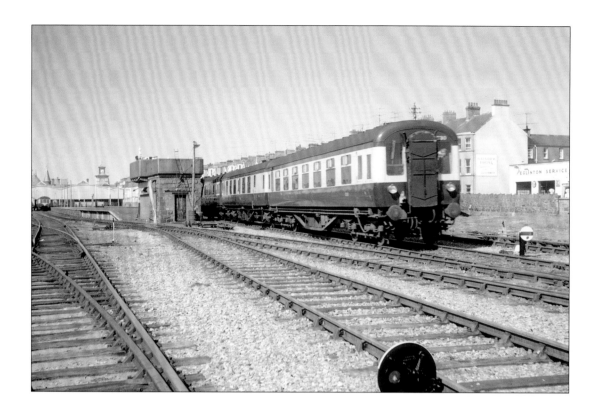

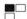

Meanwhile earlier in the day, J15 Class 0-6-0 No 186 was closer to its original stamping ground than it had been since 1965 and took the train south of Connolly to Bray, Greystones and Wicklow. On the way back to Dublin, No 186 took advantage of the superb turntable behind Bray's up platform to turn and face north again. The centre road between Bray's two platforms (see also page 48) had been a vital part of railway facilities in the steam era, allowing a ready means for tank engines to run round smartly after arriving at Bray.

In the Spring of 1968, NIR opened a new station between Coleraine and Portstewart to serve the New University of Ulster as it was then called. In its earliest incarnation it was little more than a glorified halt, but it was the first new station built by NIR and therefore a milestone in the revival of our railways. On Saturday 22 June, we see two-car MPD set 63-530 at the new halt with a Portrush-bound train. The time is 10:15 am in the morning.

On Monday 24 June 1968, Portrush branch MPD set 48-40-530 arrives with the 4:15 pm from Coleraine. The tail lamp indicates it is arriving rather than departing. The versatility of the MPD stock is well illustrated by this slide. GNR formations would have needed the unpowered trailer between the cars, as only cars 585/86 (AEC) had driving cabs. All MPD cars (apart from catering cars) had driving cabs. True, the non-corridor vehicles were a nuisance but rebuilding had largely resolved this problem by the end of 1969.

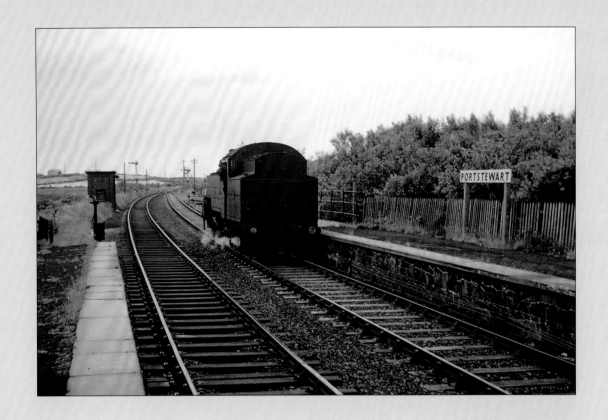

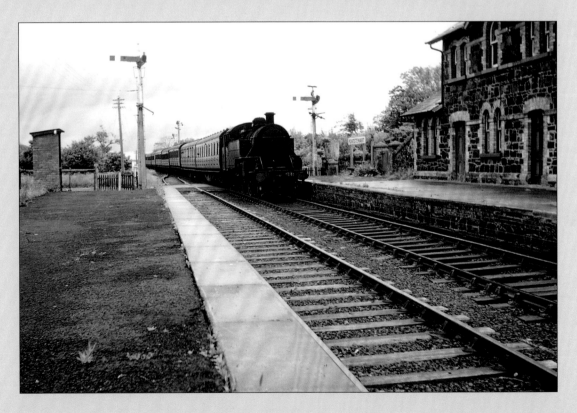

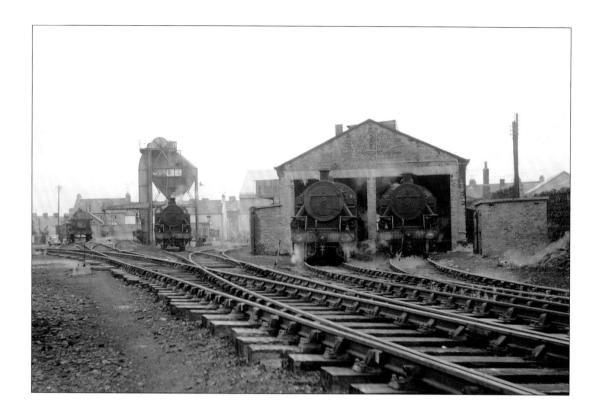

I happened to be staying at Portstewart that week and was out with my camera on Saturday 22 June to record the Sunday School specials. This was the first occasion I had the benefit of a car to get between stations and it greatly speeded things up. Thankfully, the long loop at Portstewart was still operating but by the time I arrived at Portstewart, the first train had already gone through, hauled by No 53. I got there in time to capture it in the passing loop on its way back to Coleraine.

The next engine to come through was No 50 at 12:05 pm. As it comes over Portstewart crossing, No 53 is behind me and will be given a clear road to proceed when No 50 clears.

There were three steam engines in the Portrush area that day, which I realised when I found three sets of carriages at the station, after following No 50 there. To discover the identity of the third, I drove to Coleraine and confirmed there were three engines on shed. From left to right we have Nos 10, 53 and 50.

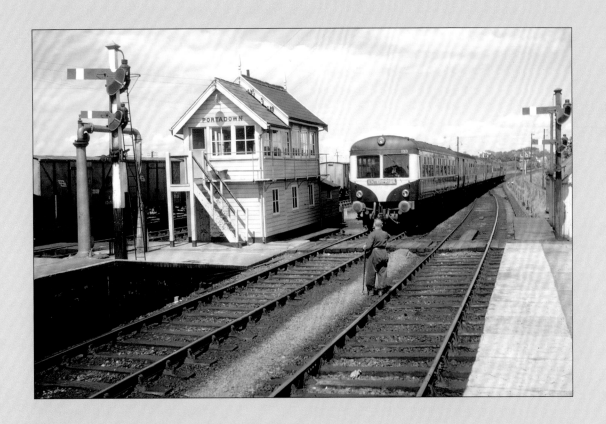

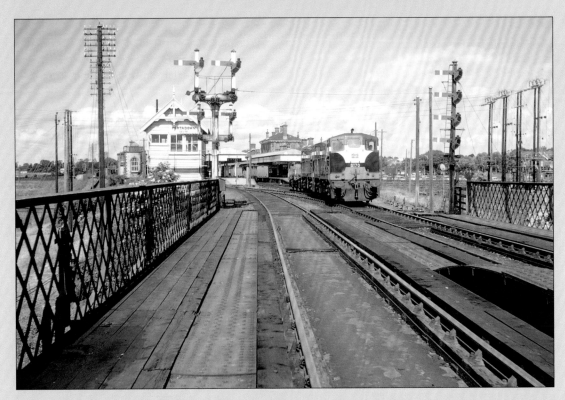

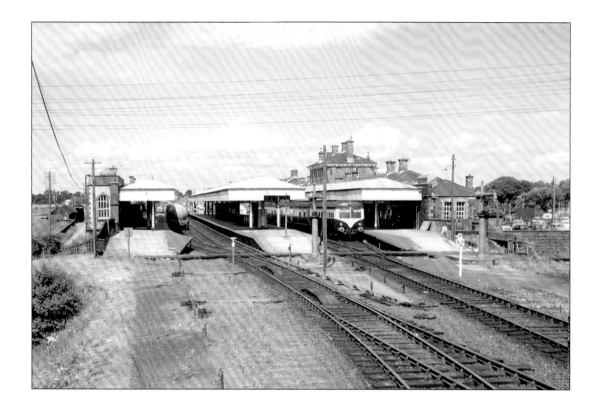

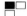

A classic railcar era scene at the old Portadown station on Thursday 27 June 1968. As a 'wheel tapper' waits between the Platform 1 and 2 roads, BUT car 133 heads the formation of the 2:30 pm Enterprise to Dublin. (133-562-552-556-123-125-584-12?). Unfortunately the last car was not identified.

At the other end of the station that afternoon, B170 and an unidentified companion had the afternoon goods to Dublin and I have moved down to the Bann Bridge to record them shunting in and out of Platform 1. This bridge had good wide walkways either side but I have positioned myself on the sunny side.

A general view from the steps of the old South Cabin with CIÉ cement 'bubbles' at Platform 1. In early NIR days most off-peak local services terminated at Platform 1. In 1968 most passengers arrived by bus, bike or on foot which was just as well as the limited car park (extreme right) would be very insufficient for modern conditions.

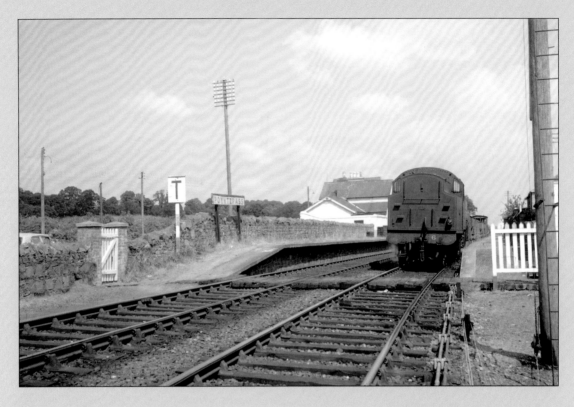

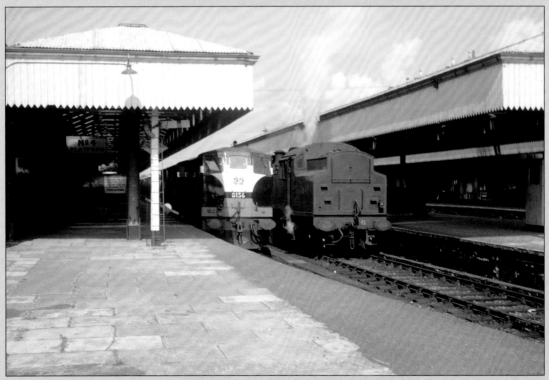

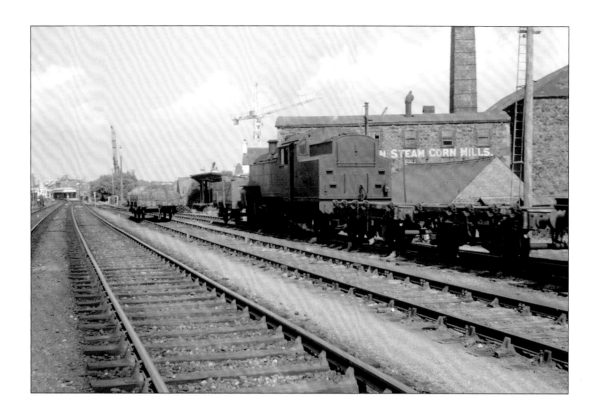

The welcome use of No 3 to steam heat the Rugby Specials in February 1968, possibly led to a decision to deploy steam engines on ballast trains. In August, NIR began some major track work between Portadown and the border and, on 7 August we see No 6 at Poyntzpass with a southbound ballast train. My blue Mk II Cortina can be seen to the left of the station gate.

In the late afternoon, No 6 returned to Portadown and, as it sits blowing off at Platform 3, makes an interesting contrast with CIÉ B156 on the afternoon goods to Dundalk.

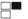

One of No 6's additional duties that afternoon was to pick up a short rake of wagons from the goods yard. Since the demolition of the goods yard commenced just over a week later, I reckoned at the time that the wagons were ballast wagons being cleared to make way for this. However, it was still possible in 1968 to get consignments for Portadown from south of the border delivered to the NIC depot at the goods yard, brought down from the station by a CIÉ diesel. A nice touch in this view is the lettering 'BANN STEAM CORN MILLS' along the side of the red brick factory – a link with Portadown's industrial past.

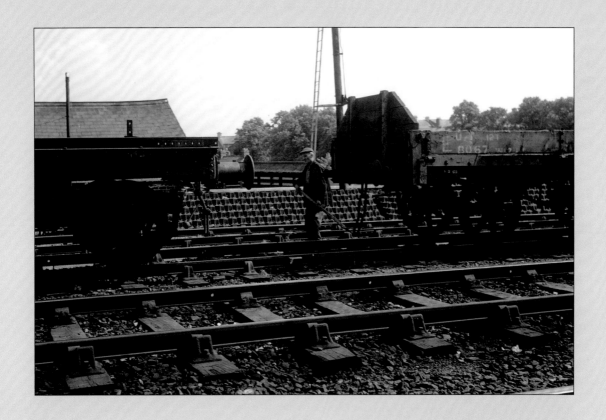

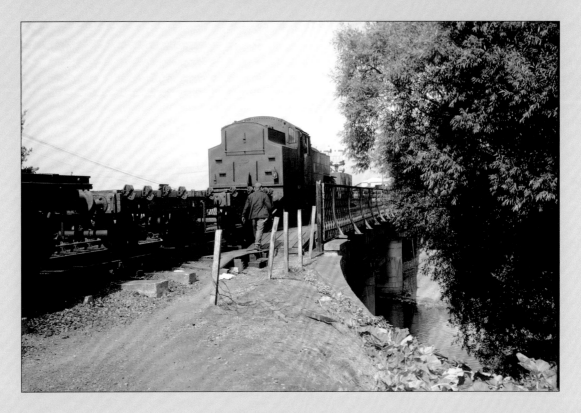

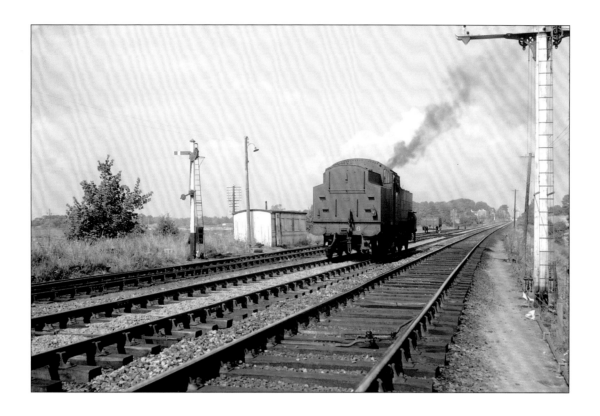

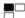

The pick up of wagons gave me the opportunity to record the time-honoured practice of coupling up loose fitted goods wagons, using a shunter's pole. As the wagon (left) is reversed towards him, the shunter stands between the buffer and coupling hook. He then hooks the wagon chain with the shunter's pole ready to throw it over the hook of the approaching wagon. Hook on, job done – only slightly less dangerous than unhooking a moving wagon!

Having completed the job No 6, propelling a single wagon, returns to the passenger station to set off for Belfast, while the shunter walks alongside the leading wagon. Down below, the Bann looks tranquil at Shillington Quay.

As she makes final preparations to set off, No 6 waits for the signal to set back and pick up her wagons. She has already deposited her red open wagon in the head shunt up the Seagoe Bank. To the right of the near signal pole, the first traces of 'Northway' can just be seen under construction near Seagoe Cemetery. Note the old six-wheel coach body in use as a line-side hut on the left.

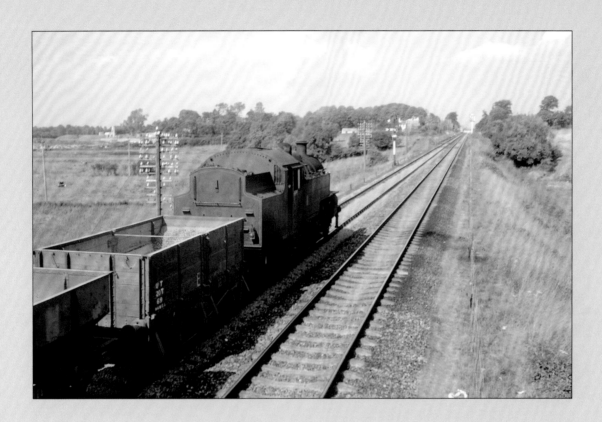

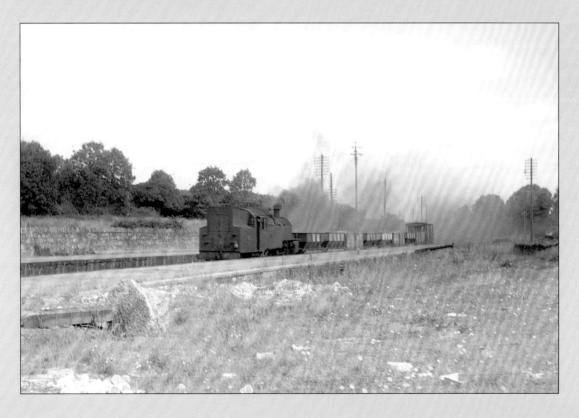

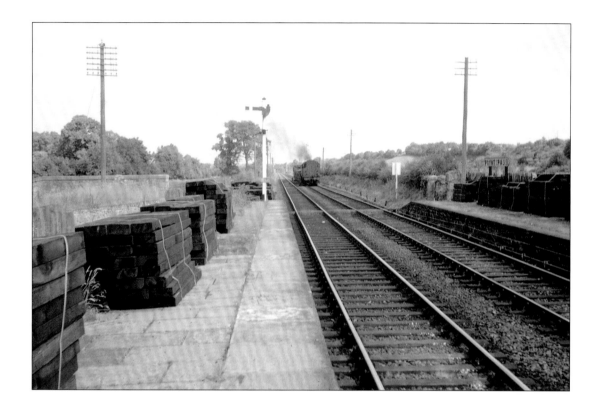

I have climbed up the up home signal for the departure shot of No 6. Note the caution signal for Seagoe Crossing still raised, even though the 'advance starter' signal above it is off. The telegraph wires and poles complete the traditional scene. Within two years this scene would be transformed by the construction of Seagoe flyover and Northway. Although there is no visible 'stour', the steam is not condensing due to the heat of the day.

On 9 August 1968, I had the pleasure of 'chasing' 2-6-4T No 55 between Portadown and Meigh (just north of the border). The first shot is at Scarva as the train rattles through, with the former Banbridge branch trailing in between the rough ground and the near platform. The train is a nice mix of high-sided wagons and more modern ballast hoppers. Scarva was famous for its topiary but none is visible here.

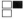

Being a slow ballast train, there was little difficulty overtaking it again, even observing the 45 mph limit required by my 'R' plate! I am already in position at Poyntzpass for the arrival shot as No 55 approaches. This shot proved useful recently in identifying a similar shot around World War One as being Poyntzpass. Note the bundles of new sleepers stockpiled on the down platform.

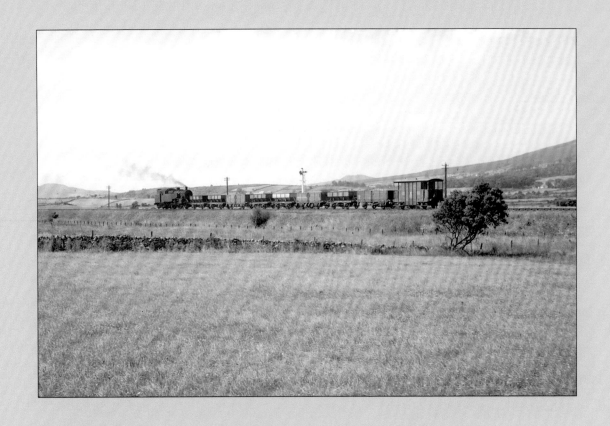

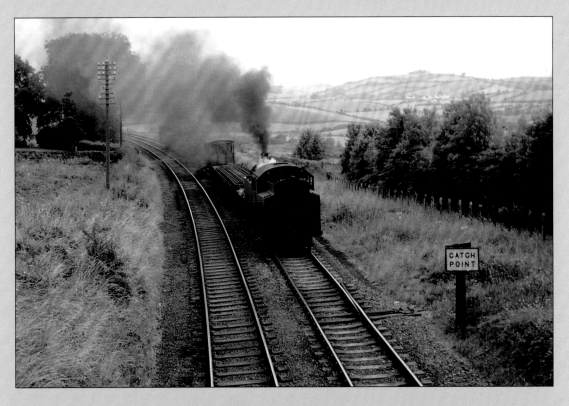

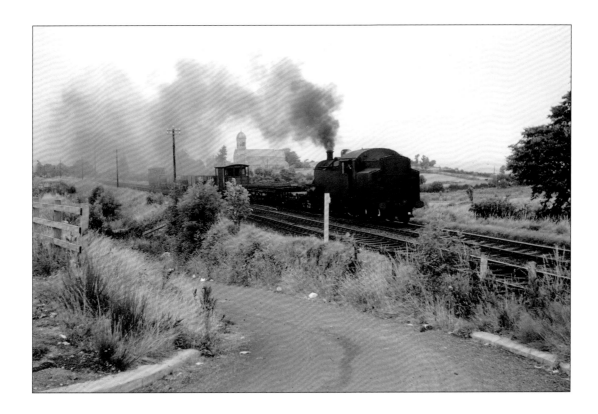

Just beside Meigh level crossing (off shot to the right) sits No 55 with its wagons. The crew are probably waiting to clear line space for the next Enterprise workings before returning to Portadown. Unfortunately the latter will require propelling. Although everything looks very tranquil here, this is not an area that would have been regarded as safe for enthusiasts for years as the intensity of the 'Troubles' built up.

On 12 August (a Monday), No 5 had the ballast so my travelling companion and I certainly had plenty of engine variety! This time I concentrated on the area between Goraghwood and the border. The first shot shows No 5 passing the catch point that was just on the north side of Goraghwood (out of view round the corner). A hint of the embankment of the former Newry branch can be seen between the shrub above the engine's roof and the green tree beyond.

The picturesque Italianate chapel at Cloghogue was a must for a line-side shot on this trip and as it turned out the smoke has curved neatly upwards as No 5 nears the 'top of the bank', thus allowing a view of the chapel. Within a few years there was a major Army checkpoint at this spot, which prohibited railway photography for many's a long year. So many of these pictures were cases of 'striking while the iron was hot' with hindsight.

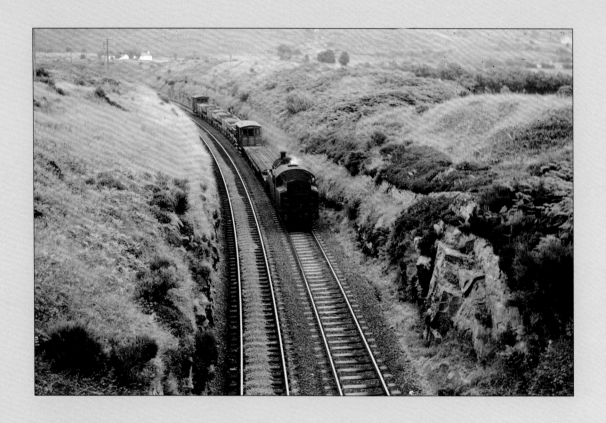

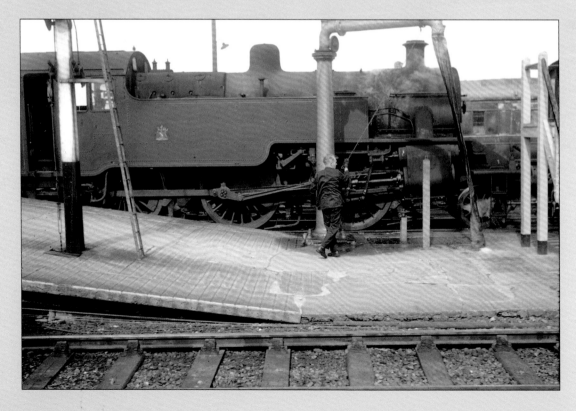

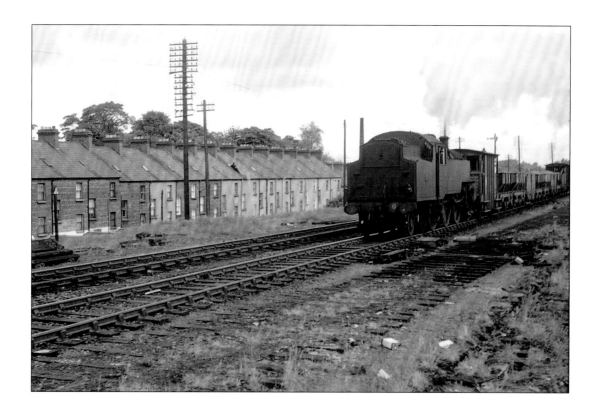

The final shot in the sequence shows No 5 south of Cloghogue about a mile further on at the top of the bank, now shut off and beginning to drift towards Meigh. There is a whisper of steam starting to escape from the safety valves.

A week later (16 August), No 6 was in charge of the ballast and she is taking water at Portadown at the Seagoe end of Platform 3. She had just arrived in from the Lurgan direction and is shortly going to be heading south to drop more ballast. No 6 was clearly not carrying the new NIR logo.

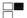

Shortly afterwards, No 6 is seen heading past the former goods yard with its train of wagons. Already, as mentioned earlier, the tracks have been lifted since the same engine picked up some wagons, and only the main running lines are left. The terrace on the left sat between the railway line and the town park and the residents of Park Road had a rather uneasy relationship with the railway, not helped by the fact that Monday, the traditional wash day, was a busy morning in the goods yard, with lots of shunting.

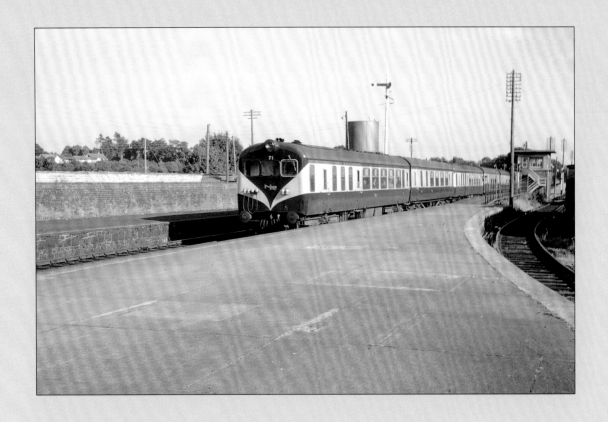

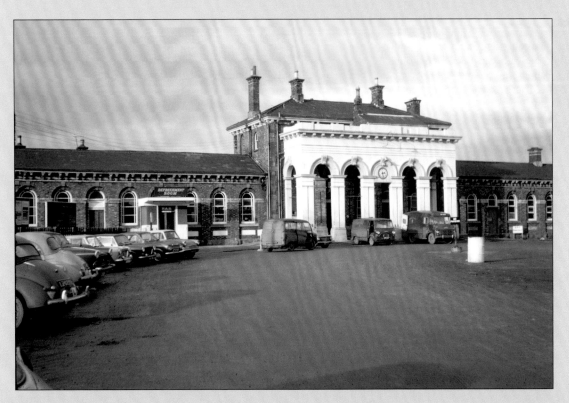

1969

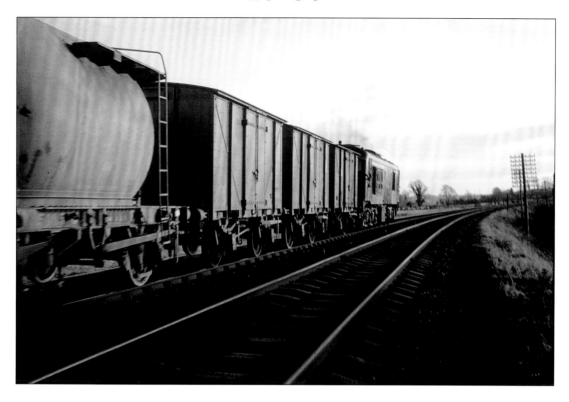

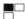

Antrim on 8 August 1968. A 70 Class set led by car No 71 arrives with the 2:50 pm York Road–Londonderry. In 1968, NIR began to replace the Northern Ireland coat of arms on the front of 70 Class with the new NIR logo. The original logo had been pure gold leaf but this offered insufficient contrast to the red so white lining was added to help this.

The soft winter's sun lends nice tones to this 3 January 1969 view of the entrance and station car park at Portadown. Despite the relatively small size of the car park, I have no recollection of ever having any difficulty parking no matter what time I visited the station. Post Office Mail vans were a common sight round the entrance. The Post Office had their own dedicated building out of sight to the right. There is a lovely selection of what are now classic cars parked, including two Morris Minors, a BMC 1100, a Hillman and a Ford Anglia. Also note the NIR Bedford van. The foundations of the original

Ulster Railway station of 1842–48 are below the tarmac about where the oil drum is sitting, but was orientated more towards Belfast than the 1862 station.

A winter's afternoon view taken on the same date but at Knock Bridge, showing A16 (unrebuilt) with the southbound 4:00 pm goods from Portadown. My recollection is that the black panel half way along the side was something to do with a film the locomotive had featured in, when it was disguised as a carriage.

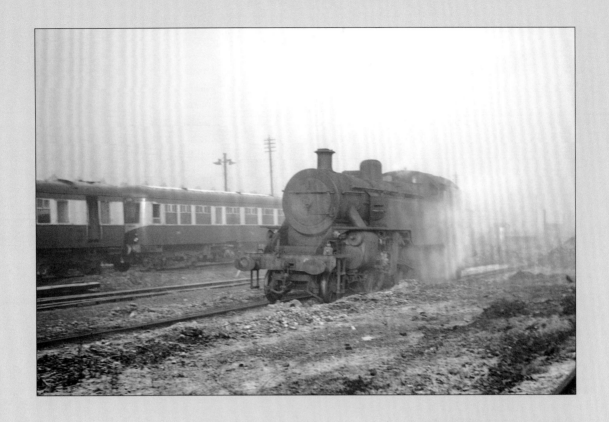

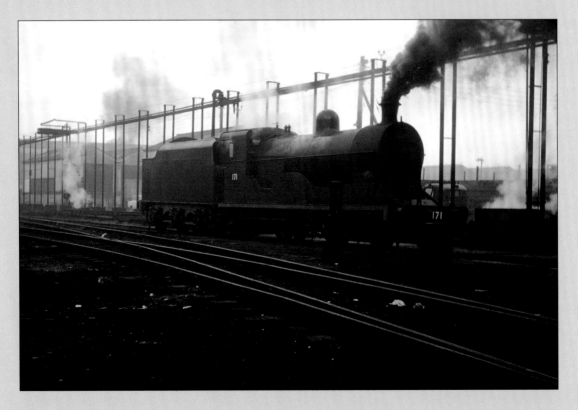

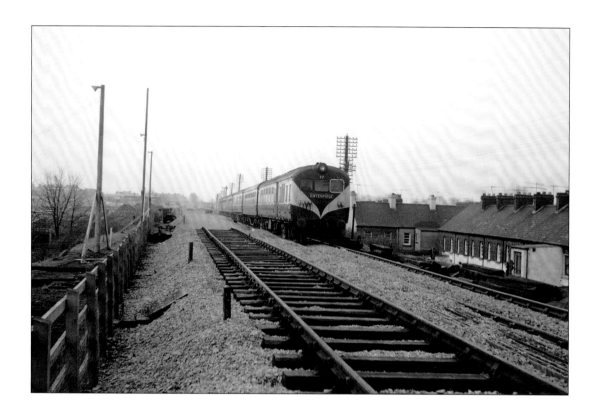

At the beginning of 1969, NIR gave up the unequal struggle of keeping a BUT diesel-mechanical eight car set in sufficiently good condition to do 450 miles a day on two round trips to Dublin. Pending delivery of a completely new train for the Enterprise, a 70 Class set from the NCC section was drafted in to deputise. In exchange, York Road was allocated a five-car ex-GNR AEC set, then nearly 20 years old. Needless to say, this exchange went down like a lead balloon at York Road, though in fairness to York Road they did actually try the set. I was very fortunate to be at York Road ten days later, on 15 January, in time to record the visit before the AECs were returned. The locomotive at the ash pit in the foreground is No 6.

On my visit to York Road that morning, an unexpected bonus was to find S Class 4-4-0 No 171 being steam-tested for the first time since its overhaul by Harland and Wolff in 1968. In this view she is in temporary dark blue and is coupled to the

4000 gal roller bearing tender intended for No 85 *Merlin* and previously attached to VS 4-4-0 No 207 *Boyne*. The steam test was successful.

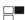

On 1 March 1969 car 77 leads a six-car 70 Class set through the on-going work at Portadown's new station. At this stage, the two main tracks are in process of being raised to align them with the future platforms and a raised bridge over Castle Street. By now the AECs had been returned from York Road, probably in exchange for only slightly less desirable unrebuilt MPD non-corridor cars. With only No 701 available for First Class accommodation, the Enterprise was severely taxed to provide for businessmen and, as a temporary measure, a standard second class side corridor coach in the 721 series, disguised with antimacassars, was added in.

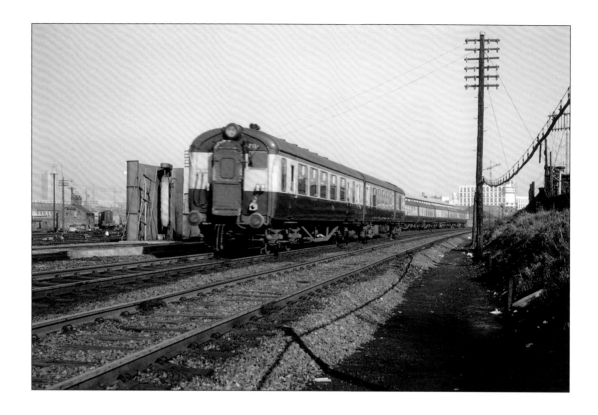

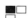

Another visit to Great Victoria Street sidings on 4 March revealed one of life's "if only we had known" moments. The main subject of the picture is B8 Buffet Car No 551 (1936), just repainted from blue and cream to be the back up vehicle for the BUT Enterprise. To the best of my knowledge, it *never* ran in its new livery, as the arrival of the 70 Class set rendered it completely redundant, though it is just possible that it might have run to Dublin on excursions. Other vehicles in view include L14 Brake Third No N595, K31 Driving trailer N585 (both in green) and a mixture of AEC and BUT cars in NIR livery.

That same day, I went down to the neck of the yard and took this view of ex-GNR 0-6-0s Nos 49 (UG) and 37 (SG3) still stabled there after over two years (see page 51), and actually looking a bit cleaner than when they had arrived. The view shows well the spacious goods yard, still then in daily use by CIÉ and well before this land was cleared to make way for 'Westlink'. The Diesel Running Shops are the white building on the extreme right and also did repairs and repaints.

To strengthen the Enterprise on a Saturday, two extra vehicles were drafted over to the Great Northern and were useful for also working off-peak locals to Lisburn. Here, with the 2:30 pm Enterprise set being prepared in the background, 78-711 arrives in from Lisburn with the obligatory oil lamp on the rear. Note the presence of 'Harlandic' No 28 on the left in the distance behind the washing plant.

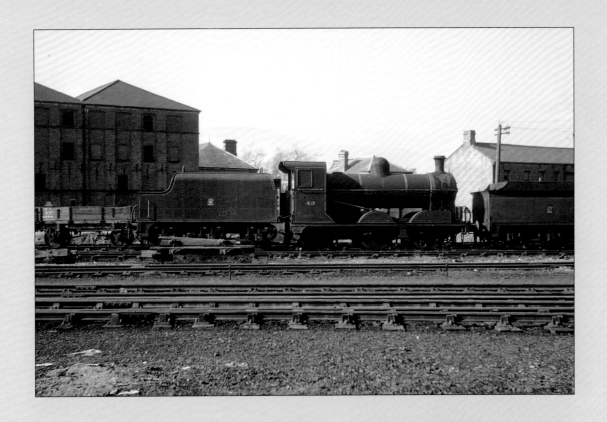

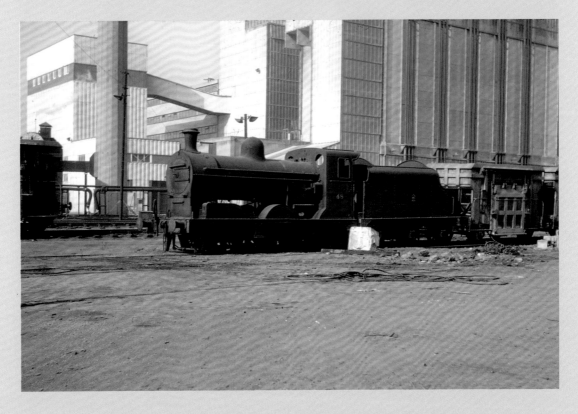

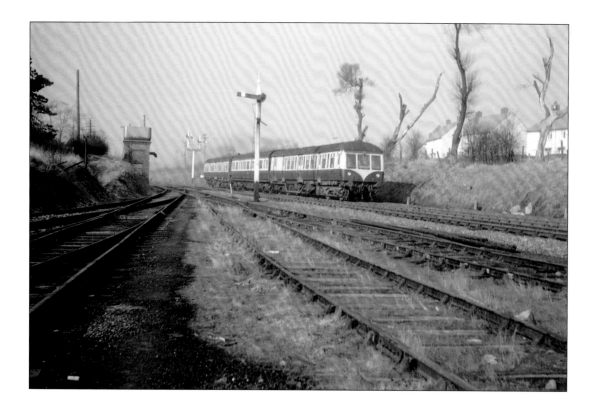

A broadside view of UG Class 0-6-0 No 49. She bears the lot number '12' so must be about to be auctioned along with her companion. For a long time, local enthusiasts had campaigned to have one of the UGs preserved but the RPSI leadership argued strongly against having another 0-6-0 goods locomotive.

No 48 of the same class had been lying at York Road since 1966 and she is captured in this view, buffered against some of the stone wagons. She had not turned a wheel since 1966 either and was to be shortly scrapped.

The west end of Carrickfergus on 6 March 1969. MED set 22-519-23 is working the 10:55 am York Road–Larne. I have my back to the tracks leading into the former engine shed. At this stage the process of providing the MEDs with new Wilson four-speed gearboxes was well under way and, as each pair was rebuilt, a non-corridor trailer was rebuilt with a centre aisle (and 'slam doors') to run with them, as with No 519 here.

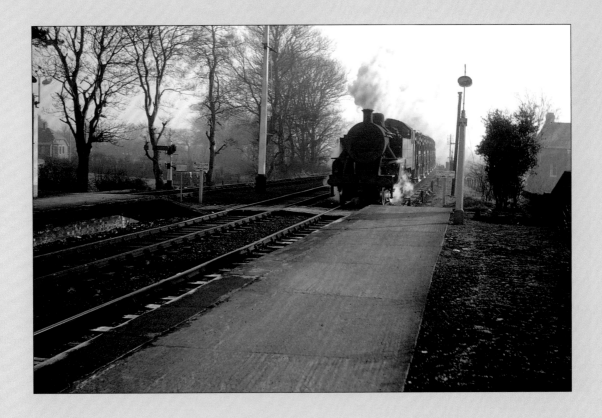

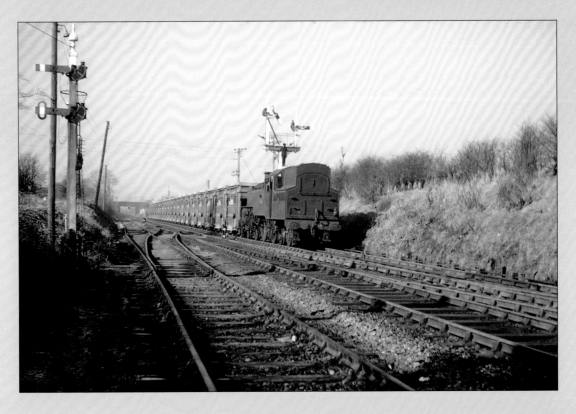

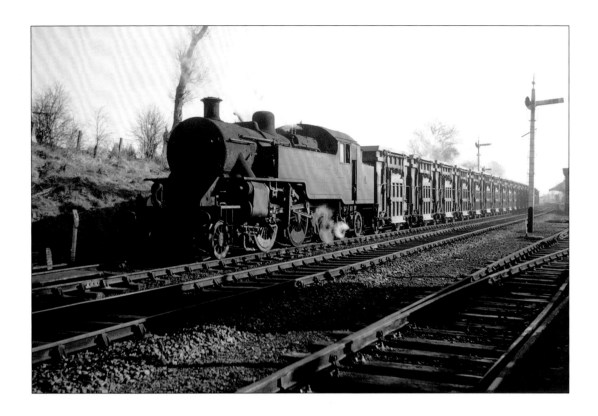

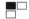

On 6 March, an up stone train approaches Carrickfergus, hauled by No 5 and propelled by No 56. This end of Carrickfergus hasn't changed as much as some locations on NIR.

Coming in the down direction, with an empty stone train, we have the same two engines between Clipperstown and Carrickfergus. The signal indicates it will be following the Platform 2 route.

A running away shot of the same train showing No 5 at the rear of the formation. Sunny afternoons at Carrickfergus could be a bit of a challenge with the angle of the light!

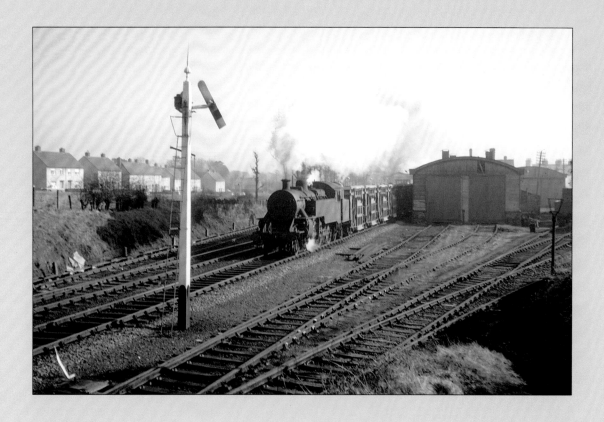

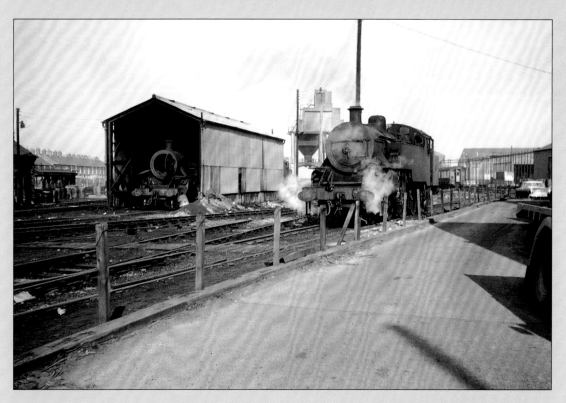

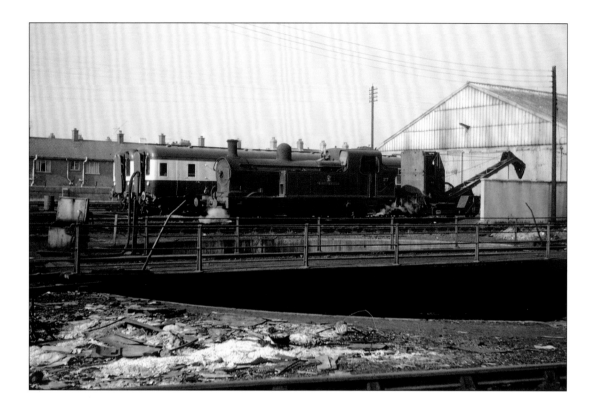

Same pod; different pea! On the same day a different stone train, this time with No 4 leading and 55 banking, steams enthusiastically past Carrickfergus, giving us a good view of the old engine shed with its small 'Belfast Roof' and the yard beyond. Both are now gone in the diesel age. The NCC somersault signal enhances the scene.

The eagle-eyed will spot three Jeeps in this view at York Road on 6 March 1969. No 3 is in the foreground and at this time was most commonly on yard shunting duties. No 10 is in the small single shed and No 55 is visible just to the left of the coaling tower.

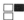

Viewed across the shed turntable, Z Class 0-6-4T No 27 *Lough Erne* appears to be coupled to the small York Road hand crane. With new diesel-hydraulic 0-6-0 shunters in process of delivery, the days of No 27 in NIR service are numbered. MPD railcars add colour to the background.

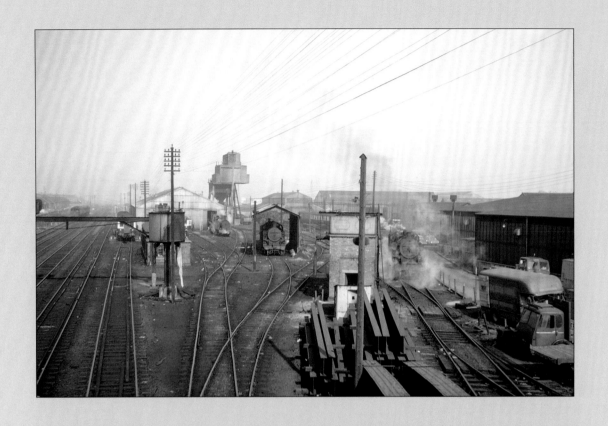

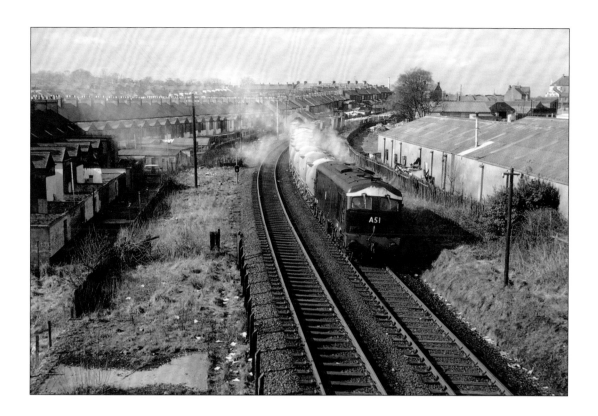

As the completion of the 'M2 Foreshore' contract draws closer, enthusiasts will not have many more months left to enjoy this view from the Milewater Road bridge. As well as Nos 3, 10, 27 and 55, this view includes Nos 50 and 54, the latter still stored after the discovery of a fault in its new firebox in 1967. Note the Northern Ireland Carriers vehicles on the right.

Following its successful steam test in January, No 171 was taken to Lisburn goods store to be painted by RPSI volunteers. It is seen there on 24 March, well into the process, though with the lining still to be completed. No 171 had the honour of sharing the shed with fellow-GNR blue 4-4-0 No 85 *Merlin*. What chat might the two engines have had?

On 25 March 1969 unrebuilt A51 heads the 4:00 pm southbound goods out of Portadown towards the bridge under the Armagh Road. It has a load of 39 vehicles, eight of them cement bubbles. For a lot of these goods engines, the 'golden brown' shade was removed from the livery with a more austere black, relieved by a white forehead.

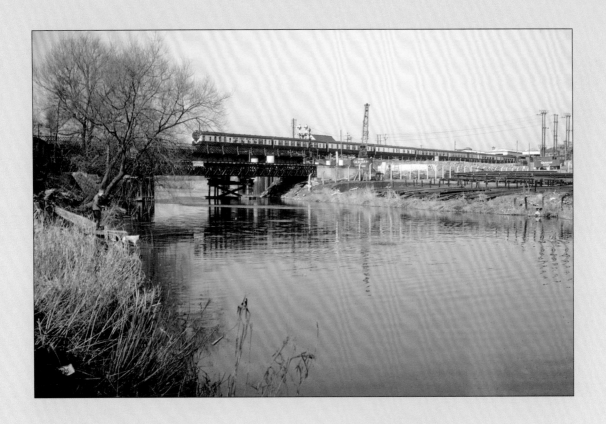

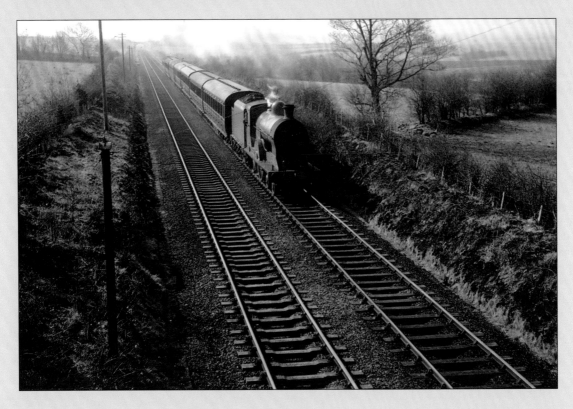

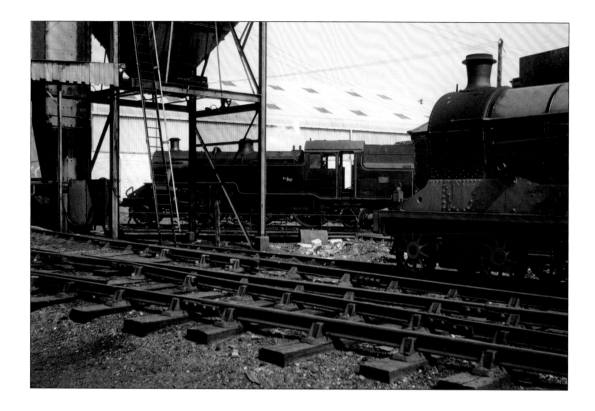

Looking rather picturesque for such an industrial area, the 2:30 pm up Enterprise eases over the Bann Bridge as it passes Portadown Foundry yard on the right. In 1968 any industrial town worth its salt had a foundry. Now the RPSI offers the only remaining such service in Northern Ireland.

On Saturday 8 April 1969, we see RPSI 4-4-0 No 171 approaching Spencestown bridge, south of Ballymena, newly repainted into GNR livery. Contrary to what the reader might think, this is not an RPSI train, but an NIR special, utilising the RPSI locomotive to operate one of its own trains as a 'running in' trip. Unfortunately, she ran a little bit hot en route and a Jeep had to substitute for the return trip.

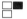

Nos 4 and 56 were also on specials that day and this colourful view shows No 171 sitting outside the shed, with a rather clean No 56 on the turntable. For how much longer would such scenes at Coleraine Shed be enjoyed?

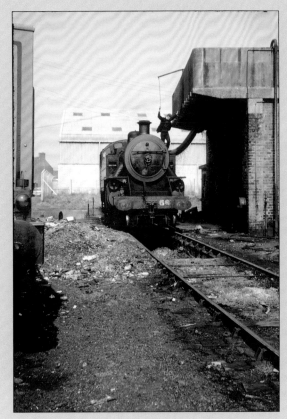

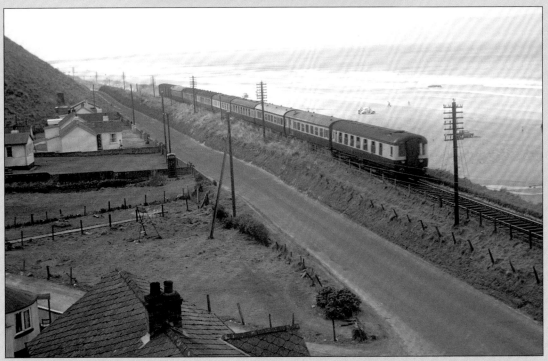

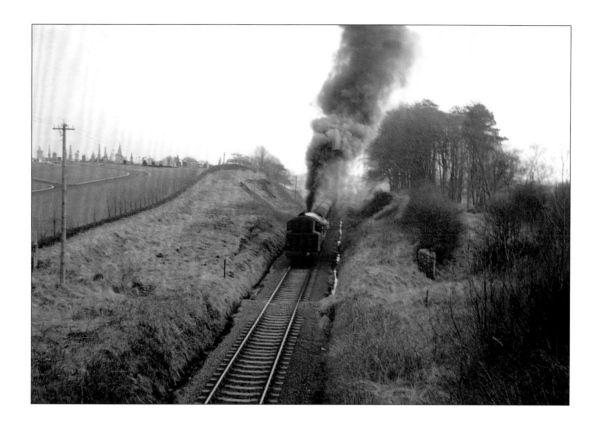

Having assisted with turning his engine, the fireman of No 56 replenishes her water supply from the tank, before returning to Portrush for an evening service to Belfast.

Downhill on 8 April 1969. A rumour started circulating that a steam train was going from Londonderry to Belfast that afternoon and quite a few went to capture it. Unfortunately, although I photographed it all right, it came bunk first, so I have not included it in the book. Instead, this is an MPD that came along twenty minutes earlier, comprising cars 43-51-538-532-548-60-57-53-614. Diner 548 was now the only working NCC buffet car, now that No 550 was on the Great Northern.

That evening, two sets of empty carriages worked back from Coleraine. This shows No 4 with its set approaching Shell Hill Bridge north of Coleraine. I am standing on the road bridge that carries the Coleraine–Portrush road over the railway.

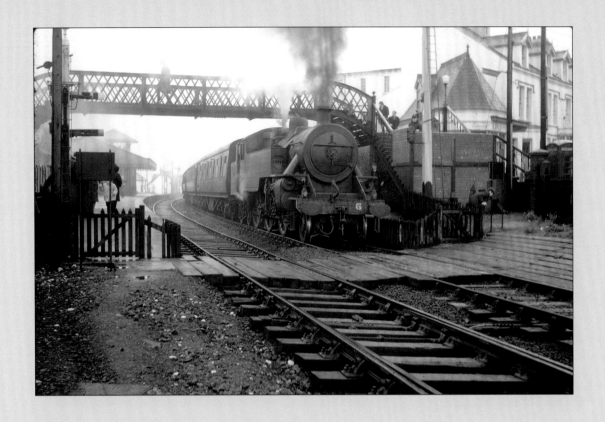

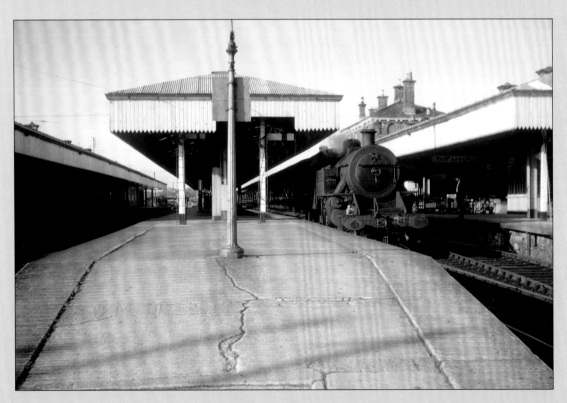

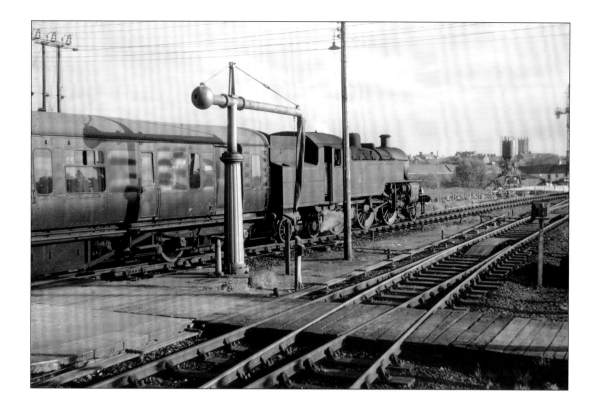

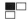

This is the Larne line at Whitehead on the afternoon of 10 May 1969. My father is just about to get off this train to attend the first Whitehead Open Day and, as a nice gesture, NIR had booked the 2:05 pm for steam to mark the occasion. Some passengers are already crossing the line via the footbridge.

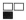

For their 1969 Sunday School excursion, the Portadown Baptists excelled themselves once again by organising a direct steam train from Portadown to Portrush, the last time a steam 'Port to Port' run was ever organised. The empty carriage set was brought down to Portadown on the evening before and stabled at Platform 2. WT 2-6-4T No 53 provided haulage round from York Road and then returned before nightfall. This view shows the train just after arrival at Platform 2 on 30 May (see also the cover photograph).

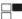

The same train from the south end of Platform 2, after pulling forward to clear the points at the other end. We are looking towards the Bann Bridge. The brake end coaches were the only two 'modern' looking vehicles with guard's vans; at this end AEC-fitted L13 Brake Third No 593 and, at the other end, J11 Tricomposite Brake 258, of which more anon. In between were mainly K15 open thirds.

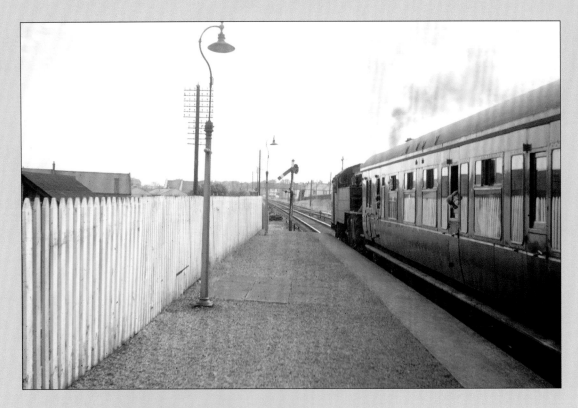

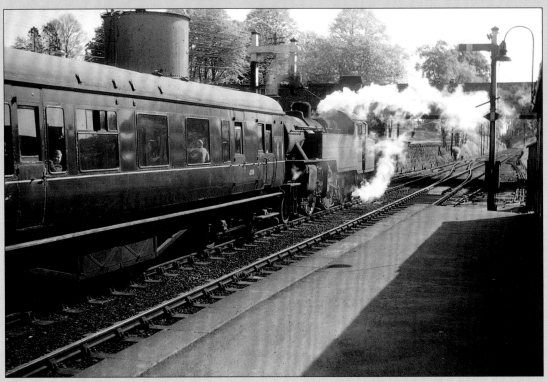

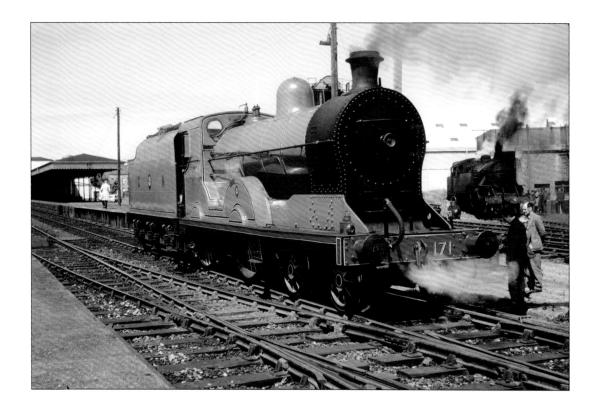

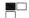

The following morning, 31 May, York Road sent
No 10 round to take the train from Portadown to
Antrim, and this provided a rare opportunity for me
to photograph a steam passenger train at Lurgan.
This slide shows J11 Tricomposite Brake 258 at the
Belfast end of the train. The slightly darker shade of
green should be self-evident. The three carriages
of this class were built in 1937–40 and No 258 was
ex-GNR 103. Nos 47 (1937) and 105 (1940) went to CIÉ.
Tri-compos-brakes were normally used as through
carriages and had single side-corridor compartments
for the 'superior' classes.

This was the scene at Lisburn that morning, with
No 10 just arrived and about to hook off and run
round for the trip to Antrim. It shows the non-
corridor side of No 258.

Another engine change was organised for Antrim,
with No 10 coming off and being replaced by No 51.
This allowed an engine to get to Portrush and back
without having to re-coal. As it happened the Baptist
excursion was not the only 'Special' in Portrush.
No 171 arrived on the RPSI Sorley Boy Railtour and
added some colour to the occasion. On shed in the
background is No 4, also at the North Coast on an
NIR excursion.

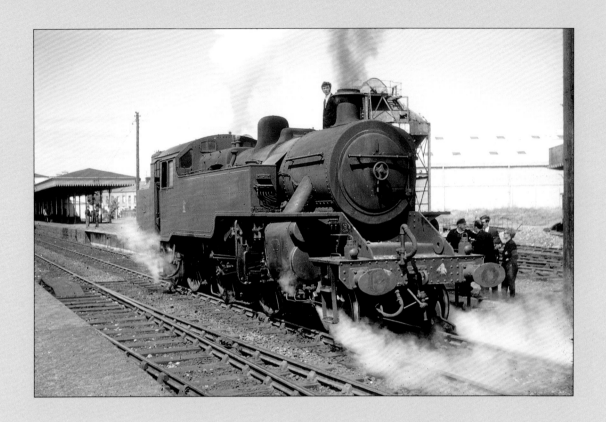

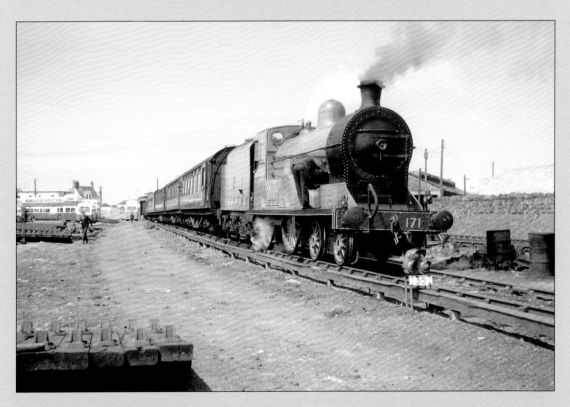

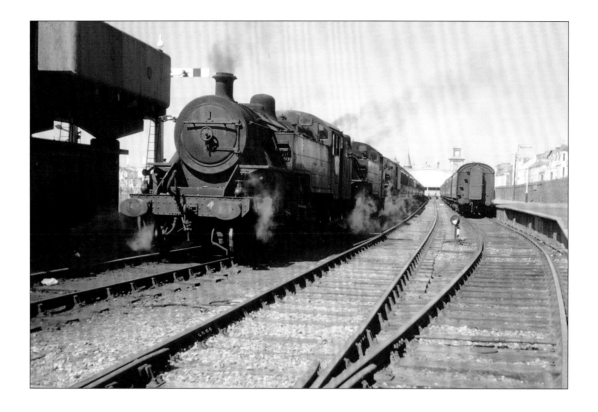

No 4 takes water at the end of Platform 2, Coleraine, attended by fireman Barney McCrory, who later went on to become an NIR Locomotive Inspector. He is talking to Roy Grayson, Bob Edwards and Jonny Glendinning (with red RPSI marshal's armband). All three men became Chairmen of the RPSI.

This view was taken just before the departure of the RPSI Special for Belfast. Four of the five carriages were 'North Atlantics', including the Composite (No 240) but not the Dining Car (549) which had begun to rot and never ran again. Note the contemporary Ulsterbus fleet, mostly made up of Leyland PD3s and Tiger Cub single deckers, with a few in the older UTA 'Eau de Nil' livery.

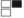

The scene late afternoon at Portrush that Saturday. To save space for local services, two trains have been marshalled together at Platform 2 and the third at Platform 1. Engines 4, 53 and 51 give the illusion of a triple header, but it is only an illusion. The departing trains left as follows;

18:40: No 53 with N370-N258-N406-N414-N412-225 from Platform 1.

19:15: No 10 with 352-N276-356-346-338-248-340-350-274-344 from Platform 2.

19:30: No 4 with 360-N380-N420-N236-N470-354-348 from Platform 3.

19.45: No 56 with 336-342-392-240-472-376-N374-402-400 Platform 1.

For some reason (hot box?) No 422 was left in Portrush.

115

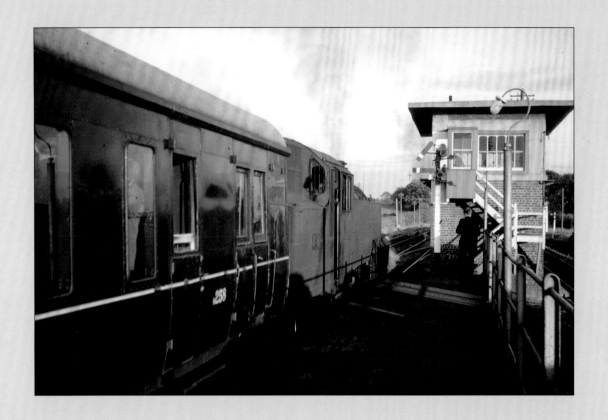

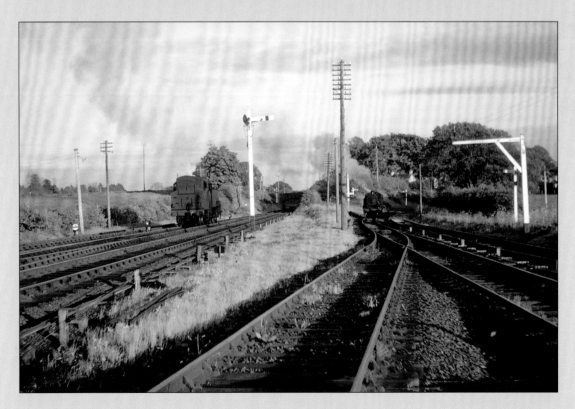

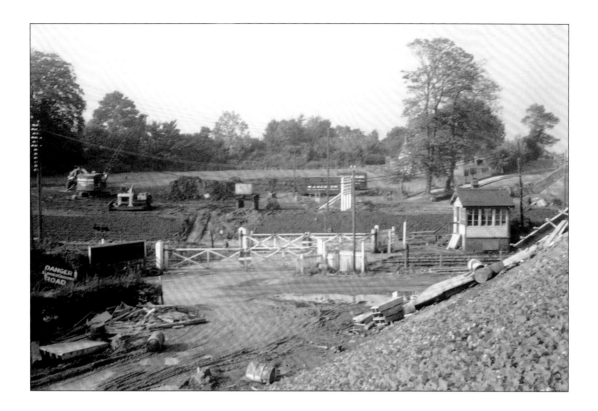

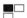

For the adventurous Baptists, the final engine change of the day was at Antrim on our way home. No 51 has just taken us from Portrush to Antrim and is about to come off. The weather continued to smile on us.

This became one of my favourite slides of all time and shows the scene at the south end of Antrim as No 51, its work done, heads off to York Road shed. Meanwhile, No 6 waits in the branch for the road to clear so that it can nose down to its train for Portadown. The day had gone perfectly! Sadly, it was to be my last big railway day of the season. The following Monday evening my father went off on the Portadown Service bus, stepped of it and crossed the road into the path of a car overtaking the bus. My father broke several limbs and ribs and was in the Royal Victoria Hospital most of the summer.

By early 1970, various significant changes were taking place in the Portadown area, mainly to do with the new Craigavon West under construction. Closely associated with that was the construction of a new internal arterial road connecting the centres of Portadown, Craigavon and Lurgan. Two lanes were to run either side of the railway. Part of the plan was to replace the old Seagoe level crossing with a new flyover that would carry the M11/M12 from the M1 to Seagoe for Portadown/Armagh traffic. In this view (11 October 1969), the crossing has just been replaced by the flyover (green embankment in foreground) but has not yet been demolished, so the original road alignment is visible.

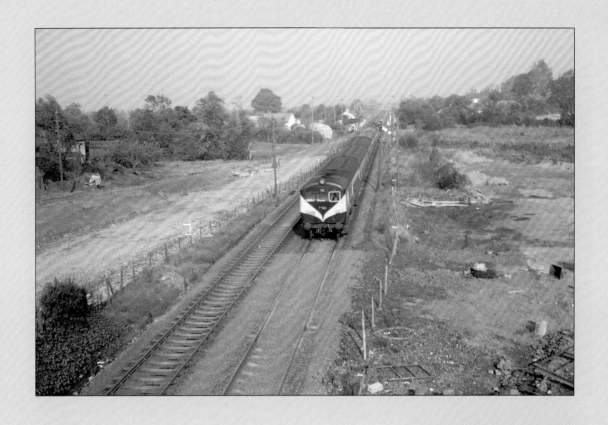

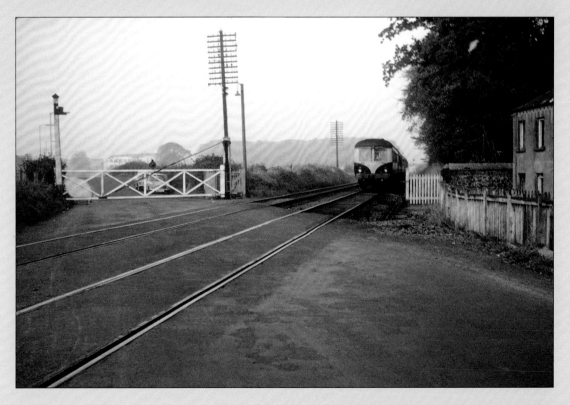

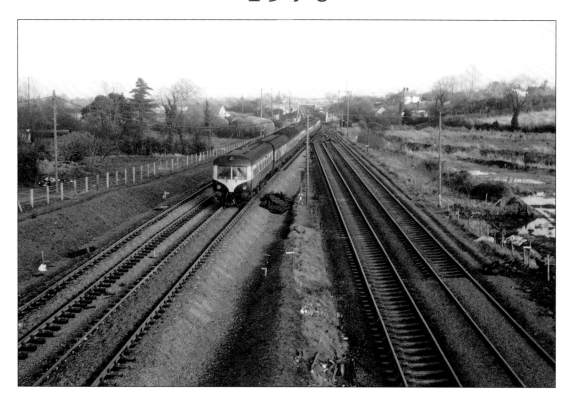

In this view, I am standing on the Flyover bridge looking towards Lurgan on the same date. Initial work for the lanes on each side of the railway is in hand but is complicated by the fact that at the other end of the flyover Seagoe Cemetery came right up to the edge of the railway. A way had to be found to move the double track over, replace the old track with the new road and make everything 'look right'. Here the 2:30 pm up Enterprise approaches the scene with car 73 leading the formation. The area to the right was once Collen's sand siding and Kernan level crossing is at the back of the train.

On 18 October 1969 a southbound three-car AEC railcar approaches Bell's Row crossing, Lurgan, with an evening train from Belfast. As the MPDs were re-engined and the AECs became ever more unreliable in the early 1970s, they began to disappear from front-line duty. Indeed, blue and cream car 111 never received NIR livery.

Seagoe on Sunday 25 January 1970, the morning the railway diversion past the cemetery was completed and operated for the first time. A seven-car BUT set takes the new turnout and cautiously moves forward.

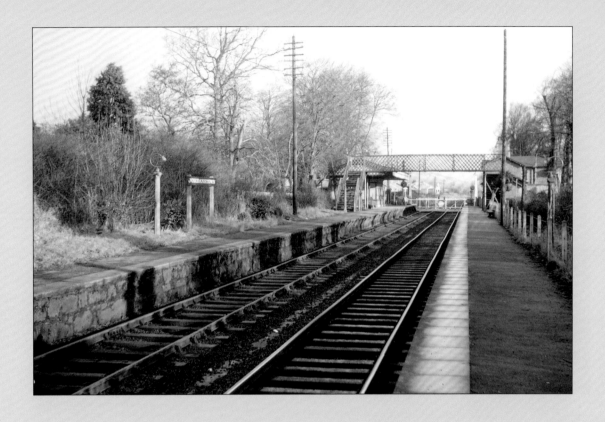

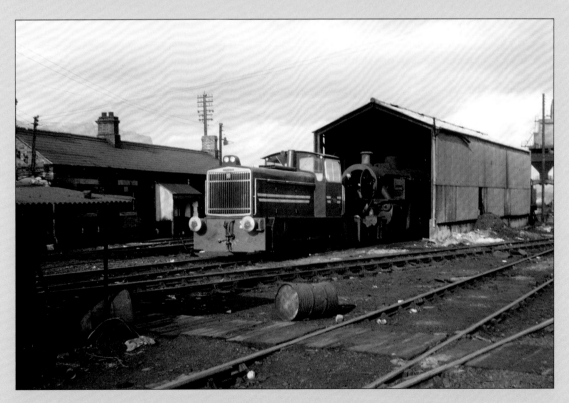

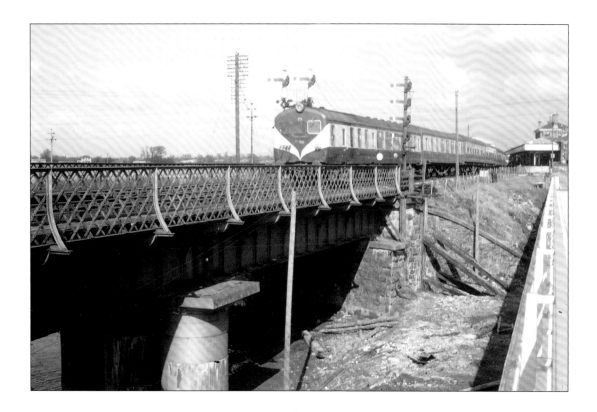

Jordanstown Station in early NIR style, 5 February 1970. By 1970 the systematic repainting of NIR stations and halts into corporate style had begun, motivated in part by the unstaffing of halts and the introduction of 'on train' conductors. The downside of this process was the reduction of facilities like a warm fire on a winter's morning in the Waiting Room and it was particularly sad to see the lovely timber Trooper's Lane station disappearing to make way for a pre-fabricated shelter.

On 5 February 1970, diesel-hydraulic 0-6-0 No 2 sits outside York Road's small shed, while an unidentified 2-6-4T receives attention to its smoke box inside. These three new locomotives were delivered in 1969 and took over a lot of shunting duties on NIR. They were rather less successful on ballast work, being too light.

Monday 23 March 1970. The eight-car Belfast–Dublin 2:30 pm Enterprise eases across the Bann Bridge passing the usual eight semaphore signals at this location. Two things were soon to disappear. By July there would be a brand-new locomotive-hauled Enterprise and in October the old 1862 Portadown station would be closed. I am standing on the new bridge carrying Northway across the River Bann.

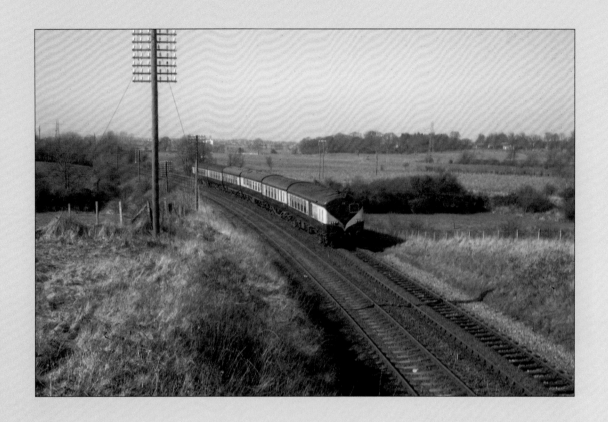

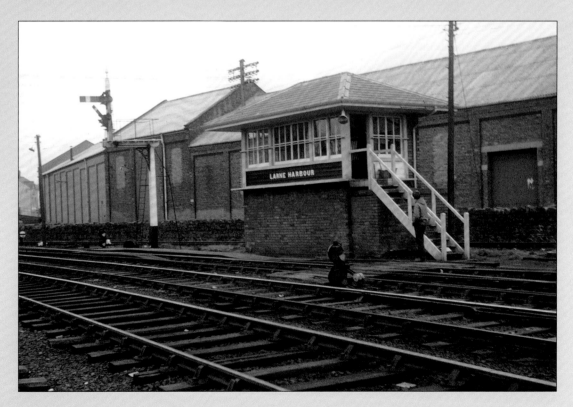

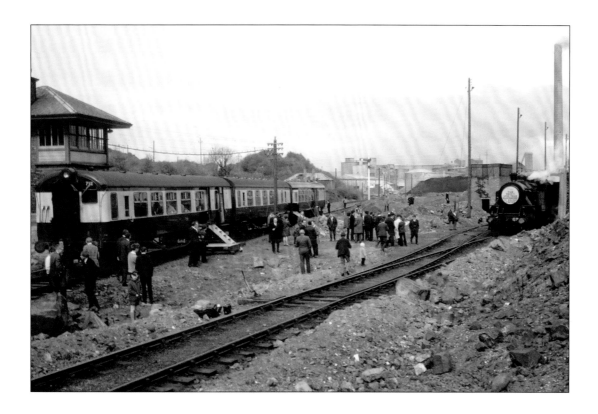

On 24 March 1970, we see a six-car 70 Class set on the 2:30 pm up Enterprise at Knock Bridge. By this time, two ex-GNR vehicles had been added to the formation, following conversion in 1969. The fourth car is Dining Car 554 (ex 403, 1951) and Open Second 727 is former K23 No 556. This had allowed Dining Car 550 to return to the NCC section.

Larne Harbour was the only location in Northern Ireland where the enthusiast could see upper-quadrant semaphore signals in action and this remained the case until the late 1970s. Their use here may have been to do with the exposed conditions on both narrow and standard gauges out of Larne. An upper quadrant 'calling on' arm is raised in this scene, as an RPSI locomotive is running round.

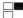

Magheramorne on Saturday 2 May 1970 saw a small ceremony to mark the official end of the contract for NIR to transport stone from there to the M2 Foreshore foundations at Whitehouse to Fort William and beyond. A three-car 70 Class set was laid on for the VIP guests, comprising DT 712, trailer 703 (probably) and a power car. Coach 703 was one of the three carriages built as Brake First side-corridor in 1966–67. However, since the NCC section needed only limited first class accommodation, only No 701 got four compartments furnished in the blue first class coquette with armrests. In the case of 702 the coach became a Brake Compo, with two blue compartments. If this view shows No 703, she was fitted out as Brake Second, with no arm rests but loads of leg room!

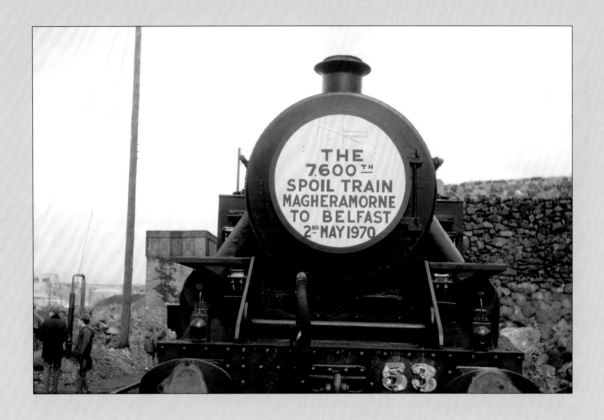

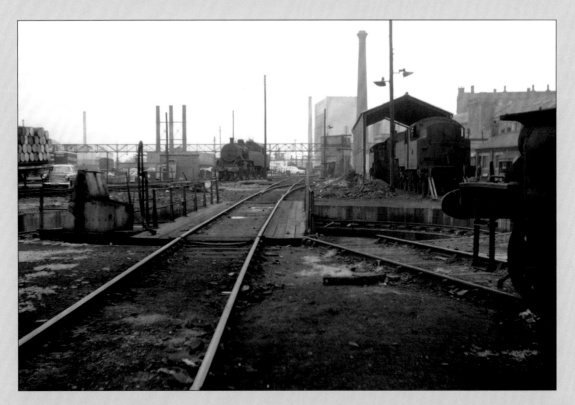

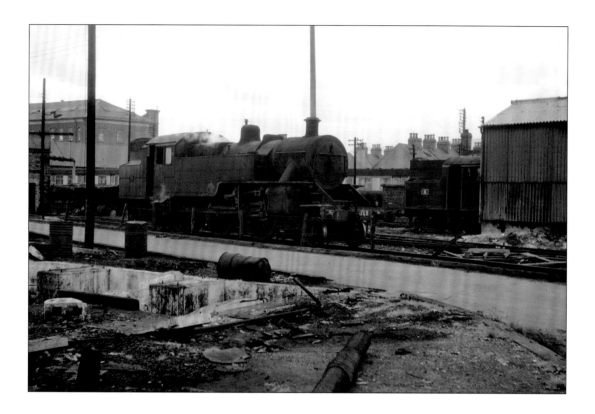

The special headboard created by the NIR publicity department for the occasion. When *Forty Shades of Steam* was written by Joe Cassells and Charles Friel in 2004, Joe proved a mine of information in logging every single train or LE movement carried out by each RPSI locomotive or engine on loan. One has to wonder who NIR consulted for the 7600 figure – or was that Joe as well? If so, it is probably right! The two engines on this occasion were 53 and 4.

The finish of the stone contract didn't automatically end the use of steam on NIR. Two steam engines were on stand by daily, though used for little more than shunting or Works Trains. In theory, it would have been possible to operate a steam passenger train but the last in practice had been on Easter Tuesday 1970. In this general view at York Road on 22 May 1970, five Jeeps are in view. No 51 is in the distance, with Nos 4, 5, and 10 in the shed, whilst No 3's cylinder and pony wheel are in the foreground. This distant view gives a good long view of the Milewater Road footbridge.

This close up of No 51 shows that the engine was in steam on 22 May, though she didn't move a wheel while I was there. Some MPD units were in the background. In a matter of months all the infrastructure seen on this page was swept away as the new stretch of the M2 was laid out. Henceforward, Whitehead would become the only steam shed in Northern Ireland (apart from obvious exceptions like the Shanes Castle Railway and Downpatrick and County Down Railway).

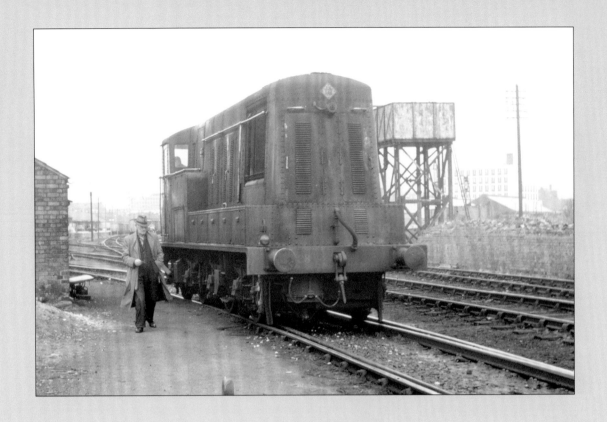

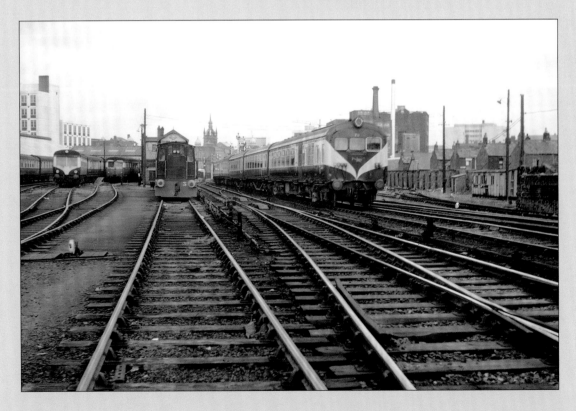

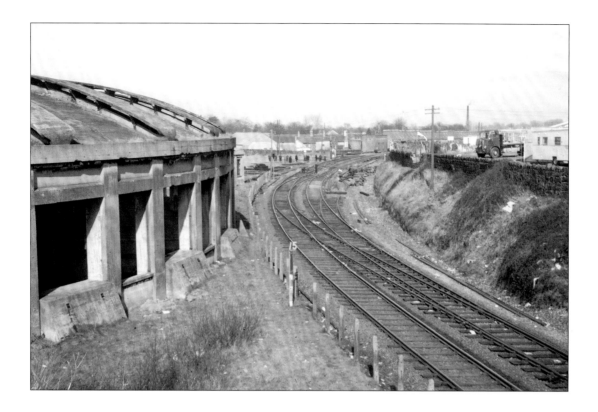

The arrival of the three NIR diesel-hydraulic shunters in 1969 didn't spell the immediate end to the use of other shunting units. Although usually filthy looking, 'Harlandic' 1A-A1 No 28 remained popular and in use. Here, on 22 May 1970, it is being driven nose-first out of Grosvenor Road Yard.

A panorama of the carriage sidings on the down side of Great Victoria Street shows that DH No 3 was there that day, even if No 28 was being used in preference. Car 73 leads the 2:30 pm up Enterprise past on the right. The sidings contain a couple of BUT sets (now all in NIR livery) and AEC 111 in blue and cream.

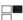

On 25 March 1970 a track gang is working beside the derelict shell of the old roundhouse at Portadown. They are installing two sidings that had of course existed in the past but are being reinstated as part of the New Station. They are still with us over 40 years on. Note the trailing cross-over between the two main lines and the red NIC flatbed lorry in what is now Magowan Buildings car park.

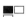

Rumours had been doing the rounds for several weeks that the new NIR English Electric/Hunslet locomotives were on the verge of delivery and I made a number of speculative visits to York Road. It wasn't just a matter of 'luck' as NIR were precious about people photographing new trains, so even if you saw one you had to act suspiciously in order to get a picture at all! When I arrived on 25 May 1970 I spied my quarry, though initially she was surrounded by senior NIR staff and I had to lie low. Then the coast cleared and I got three shots in quick succession.

This second view was slightly closer and it was obvious the number and nameplates were covered in brown paper – to hide or protect them? I could still see that the name was *Eagle*, in the usual upper case number plate style. The Hunslet Works No was 7197. My notes indicate that No 2 was shunting and that 2-6-4T No 51 was in steam, the last time I ever saw an NIR steam engine 'alive'.

Ex-SLNCR 0-6-4T No 27 *Lough Erne* on static display at the second Whitehead Open Day on 27 June 1970. Although it is often pointed out that 0-6-4T is a rare wheel arrangement anywhere, the more significant point to be made about the SLNCR version of the type is that they were the last manifestation of the old Stephenson 'Long Boiler' type, common in the 1840s and 1850s and built for the old Stockton and Darlington Railway for several decades afterwards. In the 1850s most goods locomotives had 11 foot boilers and most passenger engines, ten feet. 'Long boiler' locomotives had 12 foot boilers (excluding smokebox and firebox), and had the firebox behind the rear axle, outside the rigid wheelbase. They could be 0-6-0, 2-4-0 or 2-2-2. The horsebox in this picture was a BCDR vehicle but unfortunately was scrapped many years ago by the RPSI.

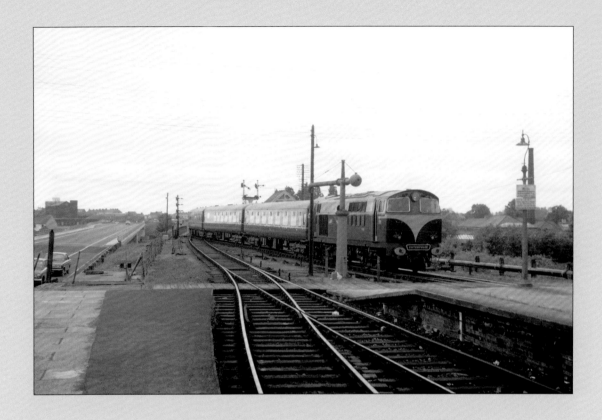

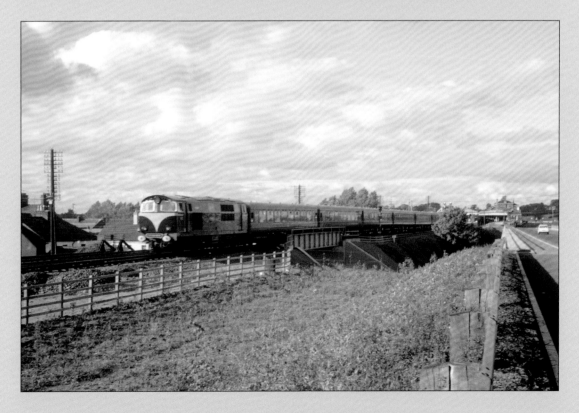

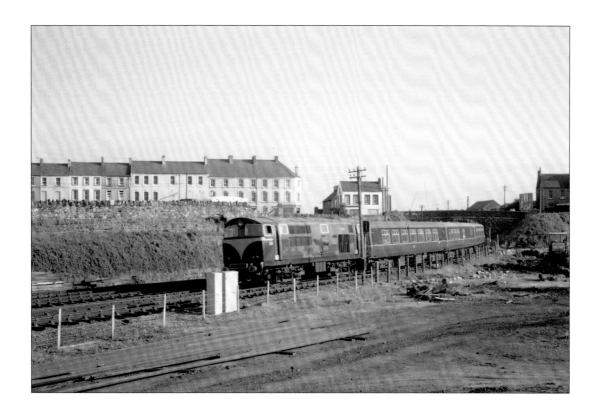

With the newly-constructed 'Northway' clearly threatening the station car park on the left, Hunslet No 101 *Eagle* arrives back in Portadown with the Press/Test train on 3 July 1970. Apart from the new road, very little by way of railway infrastructure has changed since 1967. In the press release associated with this run, Sir Miles Humphreys described the new Enterprise as "the most modern train in Europe". It may have been the *newest* train but was hardly the most modern in technical terms. However, in having BR Mk IIc stock, it probably had the edge over the contemporary CIÉ Cravens until 1973.

Next day, we see the new train again, this time showing 102 *Falcon* on the rear of the 5:30 pm Dublin–Belfast with 101 leading, as the previous day. Again Northway provides a useful vantage point for as yet there was little traffic on it, as evidenced by one car. Drivers passing the old station had to swing sharply right to avoid the car park and then left again to regain the line of the road. This was quite dangerous for railway passengers.

This is my favourite early slide of a Hunslet operating, as it gives such a good impression of the newly introduced Enterprise livery of 1970. Eight carriages were built to run with the train – First Open No 801 (leading), Buffet Car 547 (second), five Second Opens (821–25) and Driving Brake Composite 811. With West Street in the background on 7 July 1970, the train is rounding the old 'shed curve' after passing under West Street and passing the recently demolished engine shed. As reinforced concrete, this required explosives to make any demolition headway! Within a couple of years the land in front of the photographer was occupied by a major new road and roundabout, with a direct link to the Armagh Road.

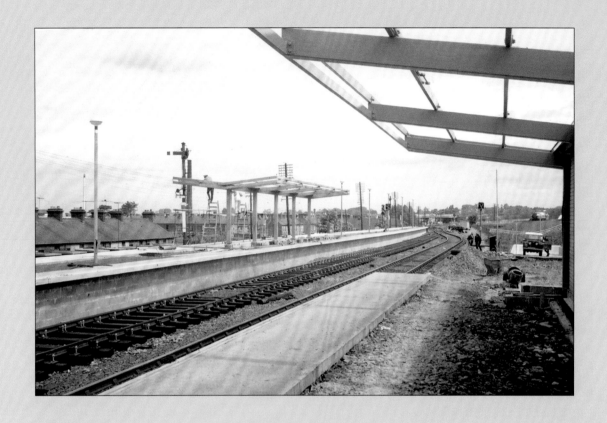

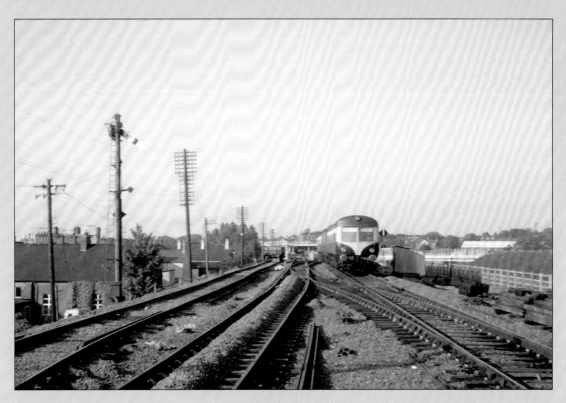

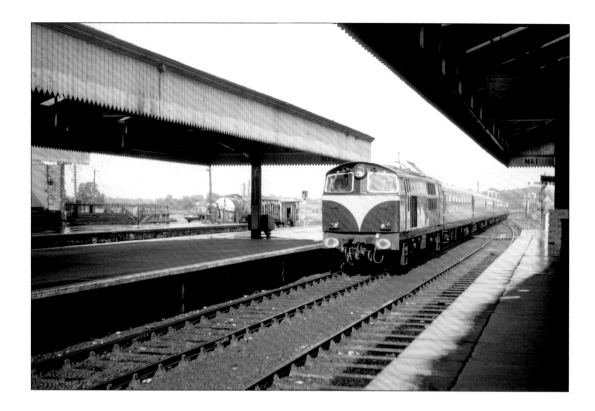

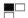

The New Station takes shape. With an incongruous semaphore down signal still controlled from the North Cabin, the new station is seen on 26 June, three months before the opening, with track work largely in place but much else still needing completed before business can start. A subway between the two platforms was in preparation but in 1970 absolutely no thought was given to disabled access and so there were no elevators and no access between platforms unless you were able-bodied.

A view from the north end of the new island platform showing the up advanced semaphore starter with BUT 131-595-127 approaching on the 6:35 pm Belfast–Dundalk on 7 July 1970. This was one of my favourite local trains as it brought the Belfast evening papers to Dundalk for points further south and returned with the Dublin papers later on, firing out bundles for Portadown, Lurgan, Lisburn and other points, en route. The siding on the left was short-lived; it was precariously close to the edge of the embankment.

On 12 September 1970, Hunslet No 101, banked by No 103 *Merlin*, arrives at the old Portadown station with the 2:30 pm up Enterprise. The station has little more than three weeks of life left and already the clerestory M1 pigeon van N609 has gone. Given the relatively few months the new Enterprise was concurrent with the old station, pictures of a Hunslet stopping at the old station seem rather incongruous with hindsight.

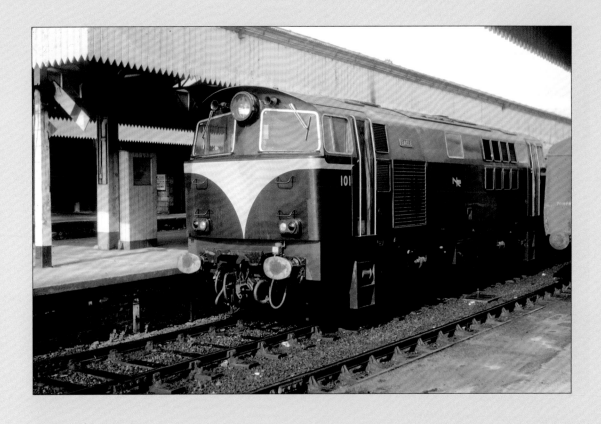

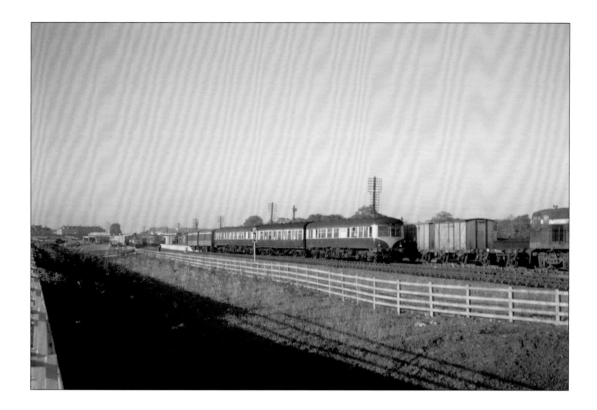

The picture says it all! Classic Platform 2 locomotive portrait with clean locomotive and semaphore signal off. Meanwhile, as the classic ex-GNR 'Y' vans become subject to disrepair, CIÉ are lending their metal-clad LVs to NIR.

The first day of the new Portadown (or Craigavon West) station was Monday 5 October 1970. With only three platforms instead of four on the constricted site, and one of those occupied by the morning goods train, there was an element of congestion. On the opening morning, a CIÉ four-car AEC train has the 9:25 am Portadown to Dublin waiting to depart. This had arrived earlier with the Dublin papers (now forwarded to Belfast) and will have exchanged them for the morning Belfast papers. A local NIR train is at Platform 1.

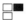

The local train is the 9:20 am to Belfast, compromising AEC cars 118-581-115, with two CIÉ LVs on tow. It is about to pass the goods engine, B176, which is in a short-lived headshunt at Park Road that was found to be unstable and was soon removed. At least with diesel haulage, the good people of Park Road had only noise to worry them, rather than the smoke and pollution of the steam age.

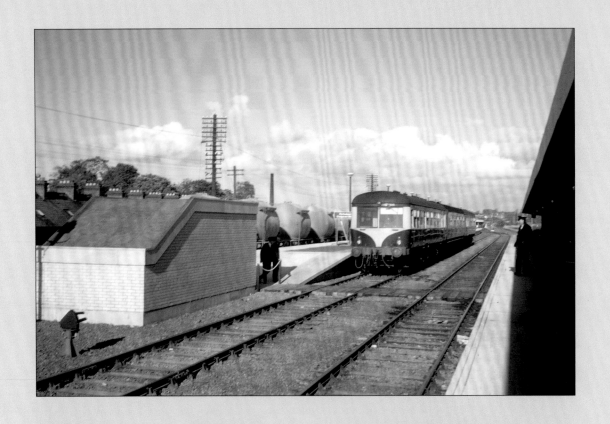

Also on the opening day, we have the familiar sight of CIÉ cement bubbles at Platform 3 and AEC set 115-581-118 at Platform 2 with the 4:20 pm to Belfast. The railwaymen can't help feeling a bit new-fangled on the first day. How long since a GNR railwayman had directly experienced a brand new station?

Absolutely no time was lost in demolishing the old (1863) station so this is the scene on 1 November as a mobile crane demolishes the wrought iron work on Platform 1. Obliterated in a matter of weeks, it had not been forgotten by those who worked at it or remember using it for many exciting journeys to places like Newry, Dublin, Clones, Enniskillen and Omagh.

In almost complete contrast, we see University Halt on 4 September 1970, still with its short modest platform and waiting shelter. We are looking towards Cromore (Portstewart) in the view.

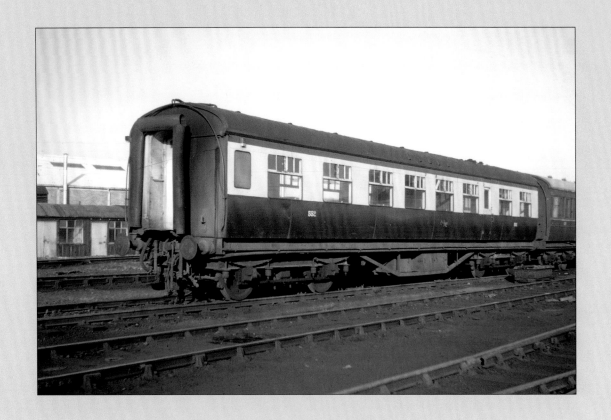

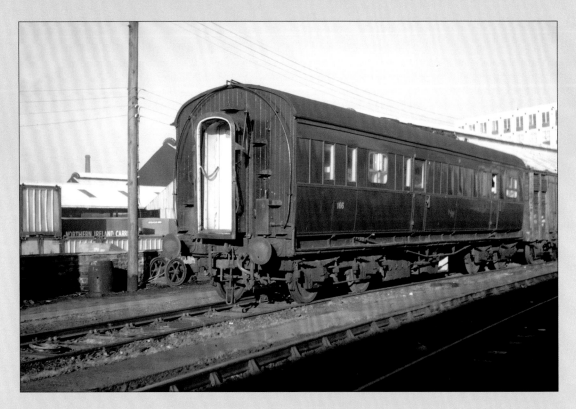

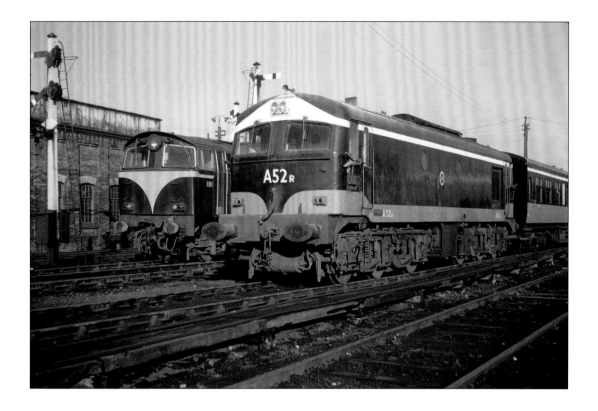

I was still very happy to get interesting views of catering vehicles and got two more opportunities at Great Victoria Street sidings on 14 November 1970. First up is BUT No 552, an ex-GNR B6 Dining Car built in 1936. It had served in the BUT Enterprise up to the start of 1969 but probably still provided meals on the 'All in' Rugby Internationals each February as they went to and from Dublin. Soon, even that era would be over.

On the same morning, I was totally bowled over to find Kitchen Car No 166 had been subject to a complete repaint into NIR red livery – note the gold leaf NIR motif half way along. As the body dated from 1902, and it still remained partially panelled (compare page 71) this was the oldest vehicle ever to be painted into NIR livery.

This slide was taken on 14 November 1970 at the carriage sidings on the up, or Platform 1, side of the station. By late 1970, the programme at Inchicore to rebuild the unreliable Metropolitan Vickers A Class diesels with General Motors 1350hp engines was under way. The 1200hp Crossley engines were removed and the rebuilt engines renumbered A52R, etc, receiving the three colour livery again at the same time. Here NIR No 101 *Eagle* keeps A52R company and makes an interesting contrast between designs, 15 years apart. The signal on the left heralds the arrival of a local train.

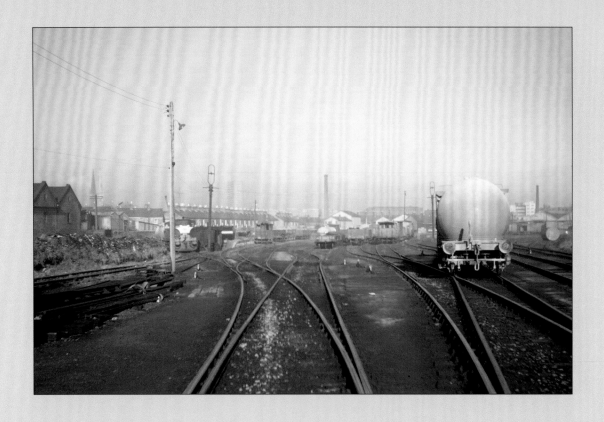

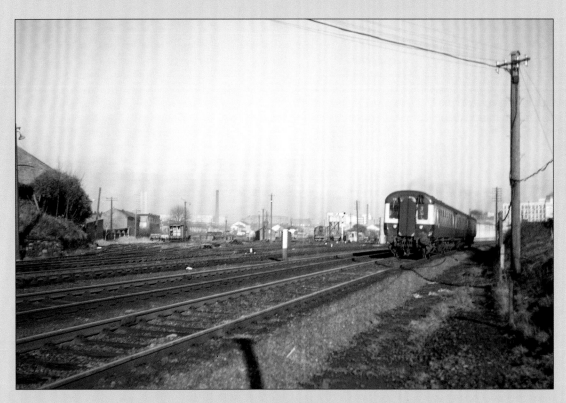

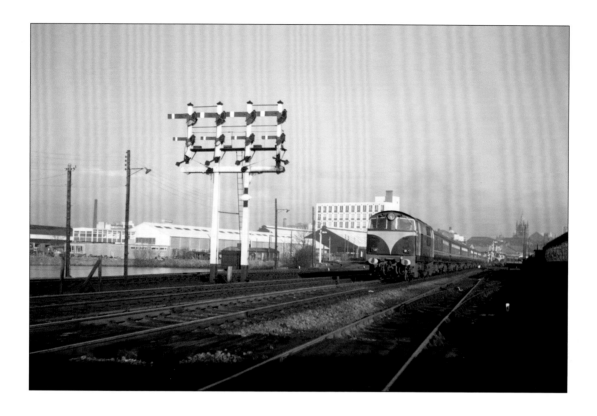

The goods yard at Grosvenor Road looks deceptively quiet in this Saturday view on 14 November 1970, with little hint that within a decade cars would be hurtling down between these rails after the area became part of Westlink. Other than the CIÉ bubbles in the foreground, most of the wagons seem to be older types.

Having hazarded my life to reach this vantage point, I am rewarded by a slide of MPD 39-532-41 on the 2:15 pm to Lisburn. Note that the two withdrawn 0-6-0s once stored on the left have now gone. At one time the interesting vehicles stored here included Gardner articulated railcar No 105 (ex-'G') and D2 Brake First No N196 of 1924.

Shortly afterwards, Hunslet Bo-Bo Nos 103 *Merlin* and 102 *Falcon* top and tail the 2:30 pm up Enterprise past the 'Duck Pond' and a lovely set of bracket semaphore signals reading to the four arrival platforms. In the distance No 101 is in the carriage sidings. Not another train to be seen anywhere. Where *is* everyone?

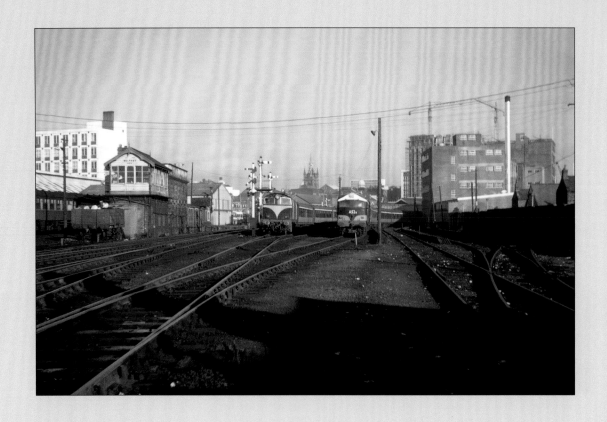

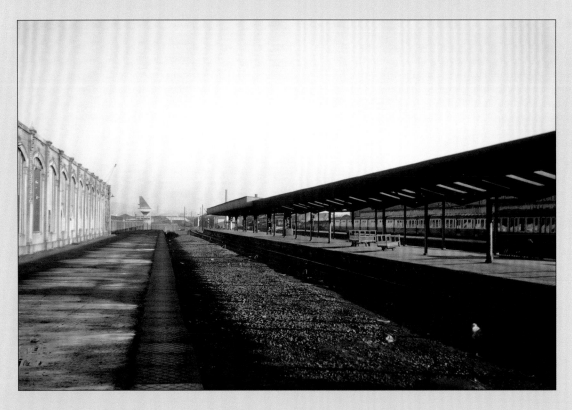

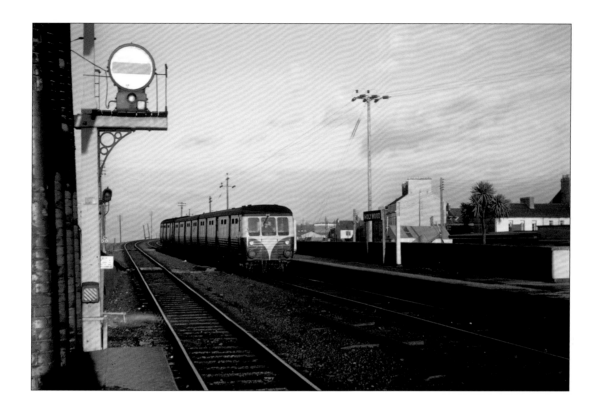

Returning to the carriage sidings visited earlier, we have another view of NIR No 101 and CIÉ A52R. One can't help but wonder if we had had enough traffic to warrant a fleet of ten Hunslets, would their reliability record have been better? The train behind A52R comprised 1347-122N-1326-168N-95N-220N-1610-225N-3124, five of them ex-GNR vehicles. Here we have a good view of Great Victoria Street's Belfast North signal cabin and its attendant water tower, used quite a bit to water carriages.

For some reason, I rarely took any photos on the BCDR section of NIR before coming to live at Bangor in 1997. The next few shots were taken in connection with a talk on NIR I was scheduled to give the Queen's University Railway Society in early 1971. This is what Queen's Quay terminus looked like in 1970 with no rails whatsoever to the former main line platforms in the foreground. In the right background MED cars can be seen at the Bangor platforms.

Holywood around 4:00 pm, with MED set 29-507-14 arriving with the 3:35 pm Bangor–Queen's Quay. The Bangor line had its own peculiar 'banner signals' and on the left is the down starting signal for Marino.

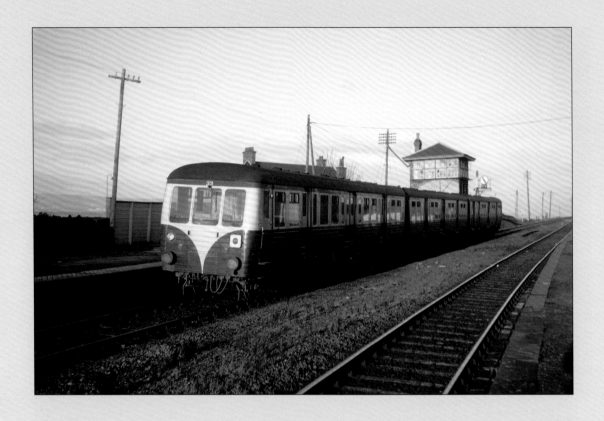

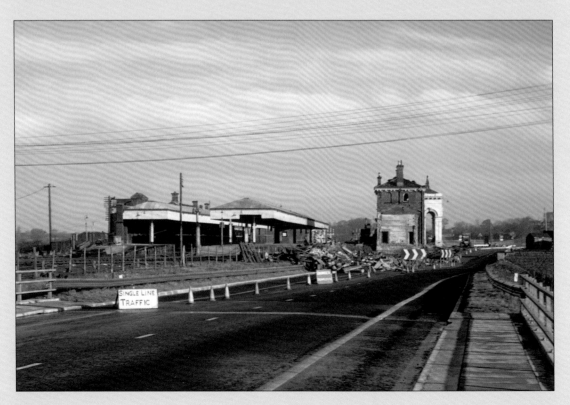

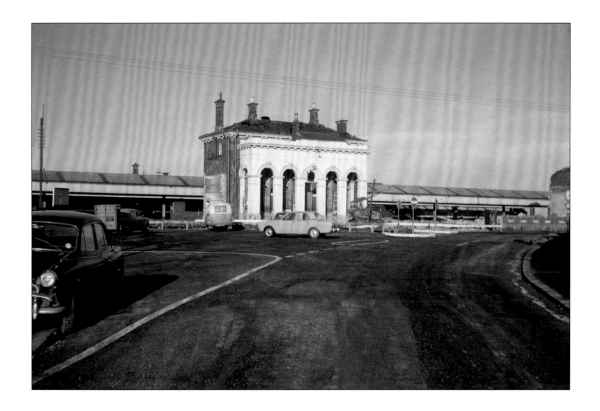

Still at Holywood but now on the up platform, we
see 32-504-33 with the 3:50 pm Belfast–Bangor.
Note the banner signal beside the signal cabin is
now in the off position. As far as I could see, the
BCDR workshops had completed the job of fitting all
their MEDs with Wilson four-speed gearboxes and
painting them into NIR livery. The wide gap between
the tracks at Holywood goes back to the run round
loop used by local services in steam days.

We return to Portadown for another view of the
demolition of the old station, this time with two
platforms still intact but Platform 1 largely gone.
Northway has now only a slight wobble to get past
the portico.

The station car park on the same date with all but
the portico and the Post Office building gone from
Platform 1. My trusty 'lagoon blue' Ford Cortina
occupies pride of place. On the left is an old Austin
Westminster.

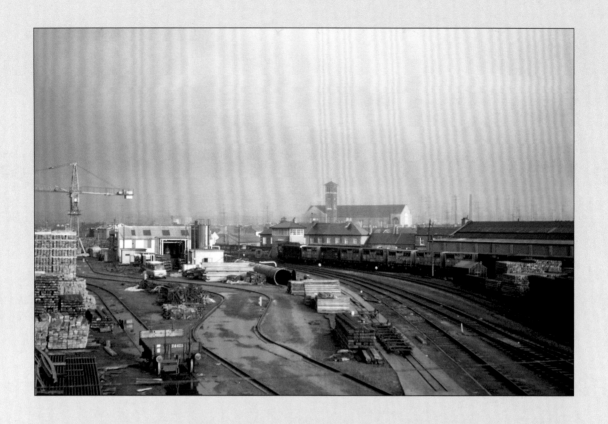

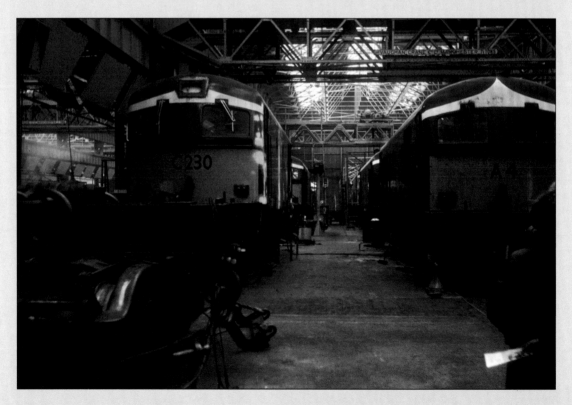

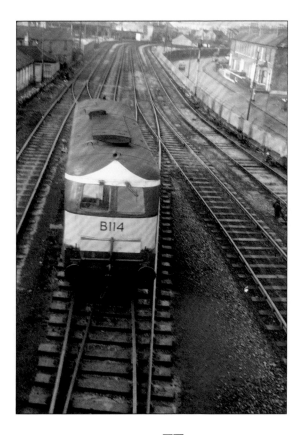

During my last two years at Queen's University, I and a group of students formed the Queen's University Railway Society and began organising outings to places like the Keighley and Worth Valley Railway and Inchicore, Dublin. As part of the latter, we visited Dublin on Wednesday 25 November 1970. This first view was taken at the former LNWR Yard in the docks and shows E416 (dead centre distance) shunting a train of cattle trucks with Church Road signal cabin beyond. This was very near the end of this traditional traffic as the movement of live cattle by train ceased in 1975 and from then on animals were slaughtered and refrigerated before export. On the left is CIÉ's sleeper creosoting plant.

Inside 'Diesel No 1 Shop' at Inchicore in the age when the Unions dictated working practices and all sorts of inefficiencies were the order of the day. The process of rebuilding the A Class continues and A4, A14, A11 and A13 form an orderly queue on the right. To the left the rebuilding of the C Class has also commenced and we have C230, C232 and A2R.

A very fortunate opportunity presented itself at East Wall Bridge when we were observing passing trains and to our delight along came B114 on its way to Inchicore. This was one of the two pioneer CIÉ main line Sulzers, built as Nos 1100 (B113) and 1101. This was the only slide I ever got of one of these 1951-built engines.

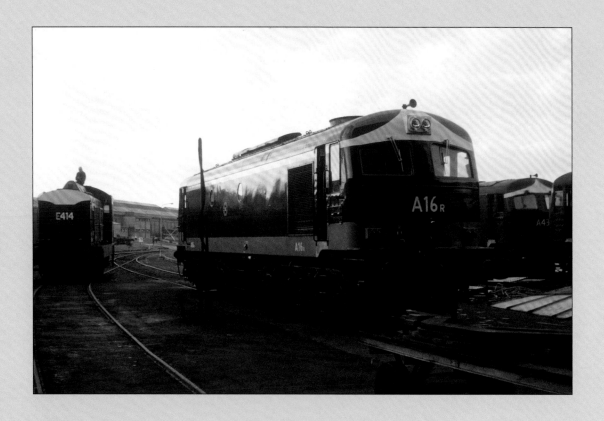

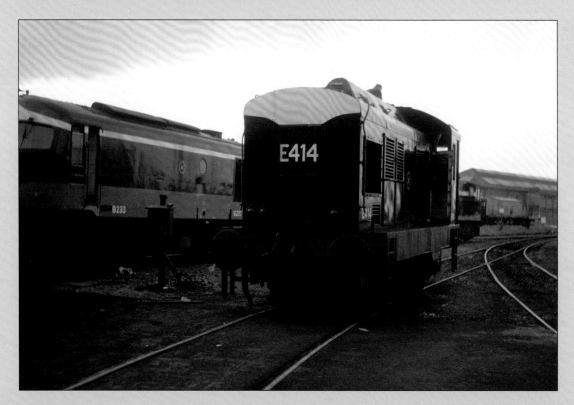

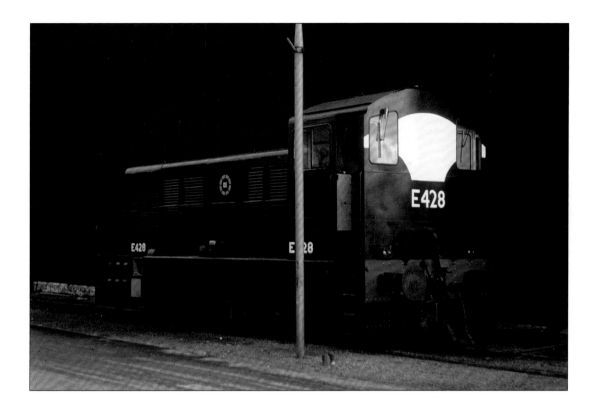

At the rear of Inchicore Works there was always plenty going on. In the left background is Maybach shunter E414, one of the original 1957–58 batch. The main subject is newly rebuilt A16R, pristine in ex-Works finish. In the background two unrebuilt A Class form part of the Inchicore (sound) barrier.

E Class Maybach shunter No E414 appeared in the background of the previous picture and was one of a class of 19 built in 1957–58, but sadly none were preserved. They were CIÉ's heavy shunting type, surpassed only by D301–05, which were designed for trip work. Of these, D304 was still running in 1970. To the left is B233, a C Class Metro-Vick that had been rebuilt in May 1966 with a 980hp Maybach MD650 engine.

Somewhat neater in appearance than the E401 Class were the E421 Class, built in 1962–63. These had a flat bonnet and gave clearer lines of sight for shunting manoeuvres. Five examples are preserved, including E421, which is on the Downpatrick Railway.

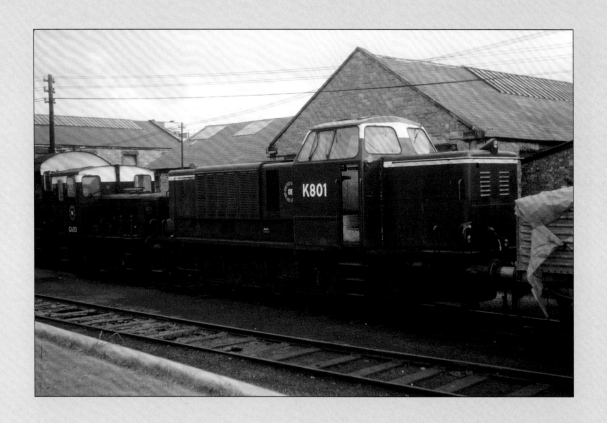

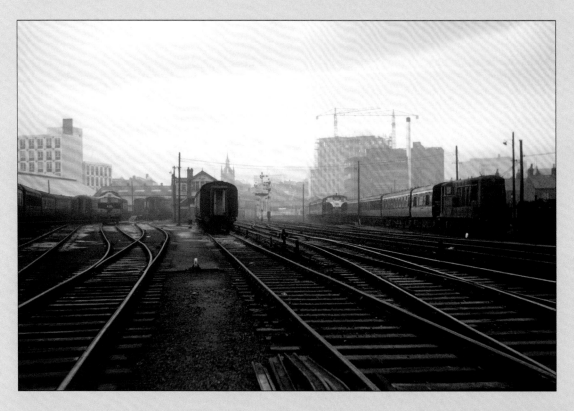

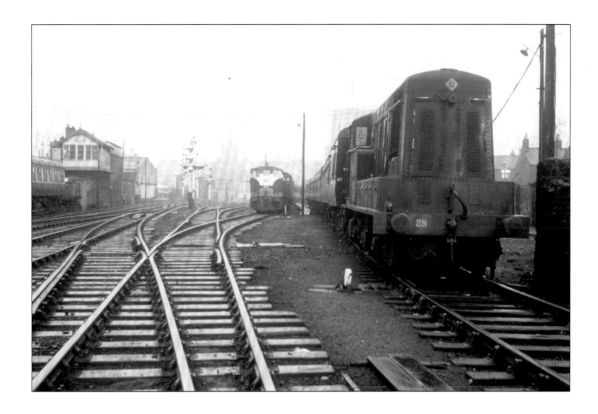

Everyone on the outing was delighted to have the opportunity to see ex-GNR MAK diesel-hydraulic No K801, originally GNR No 800. The number gave a clue as to its horse power! It is seen here at Inchicore, keeping company with G601 one of the three original G Class Deutz 0-4-0s of 1956–57 and the only one of the three still in traffic in 1970. The MAK diesel had been built in 1954 and was bought by the GNR as a freight engine, though it could not compete on equal terms with a C or D Class steam engine.

An interesting view of the approaches to Great Victoria Street station on 28 November 1970. The two CIÉ diesel locomotives are A29R and B147. With the rapid spread of the AR Class, the B141 was becoming a less common sight in Belfast. The main point of this picture is that it shows 1937-built Harlandic No 28 still active in late 1970, well after the three diesel-hydraulics had been delivered. The reason for No 28's continued use was probably simply power. The new engines struggled to shift eight coach loads of the type seen here.

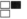

How would No 28 have looked if someone had been given a day to thoroughly clean her? Even half a buffer beam has made a difference and, as an ex-BCDR machine, what a candidate for preservation! Here she is actually shifting this long rake of CIÉ carriages and what a racket she was making.

1971

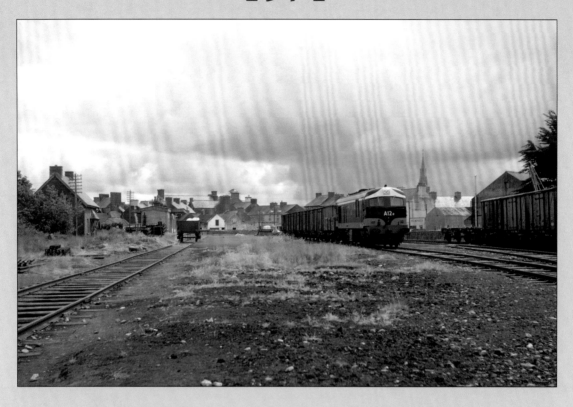

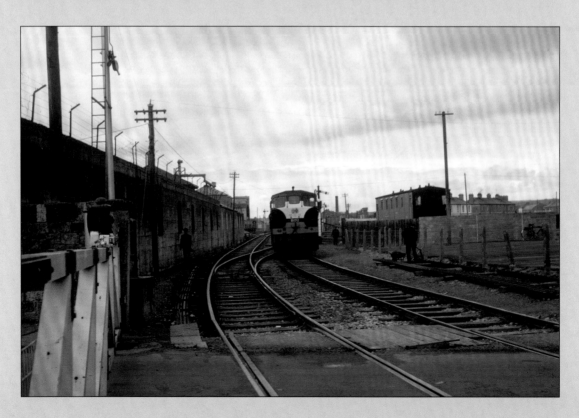

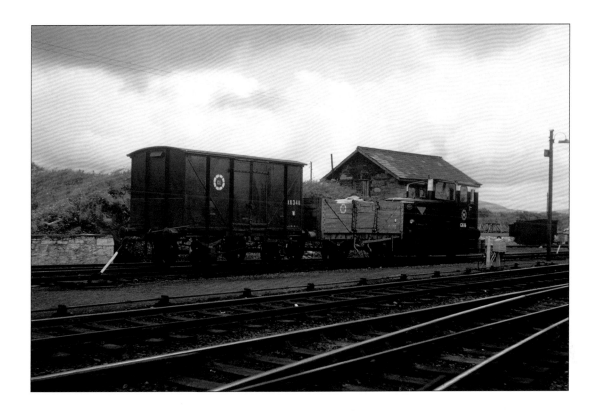

There now follow some pictures taken on a trip down south in June 1971. At this time the North Kerry line was still open for goods traffic and I was delighted to find that A12R was at Castleisland shunting the daily goods train, mostly made up of closed vans. Supporters of the Downpatrick Railway will not need reminded that the Castleisland branch was the original stomping ground of their ancient 0-6-0T No 90.

Likewise, at Tralee the North Kerry yard was still in use. B192, the newest General Motors diesel on CIÉ had worked in on the 9:45 am Cork–Tralee and was busy shunting the North Kerry Yard. Today the track beyond this level crossing is lifted.

Also active in Tralee that day was resident G Class shunter No 616 from the second (1962) batch and I remember her as brand new at that time. Her train, with one steel van and a wooden open wagon is so typical of CIÉ goods traffic in that era.

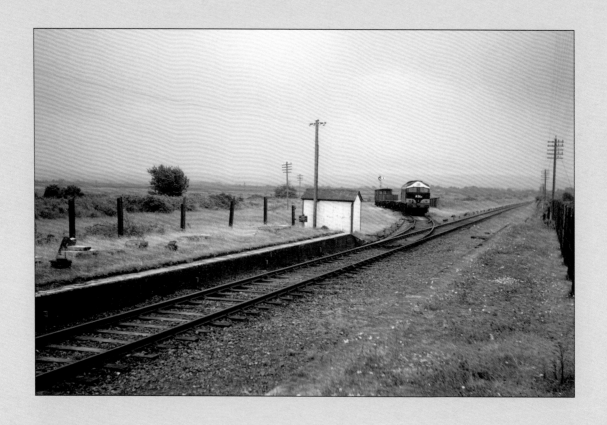

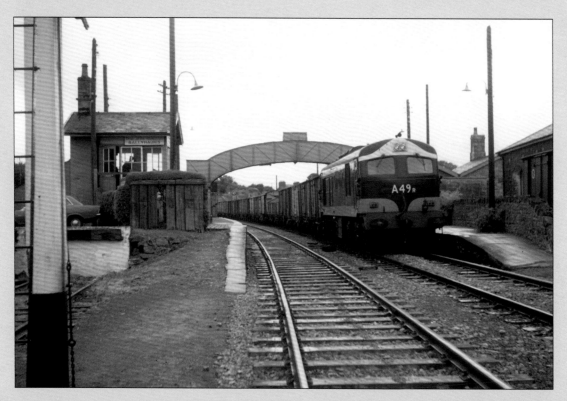

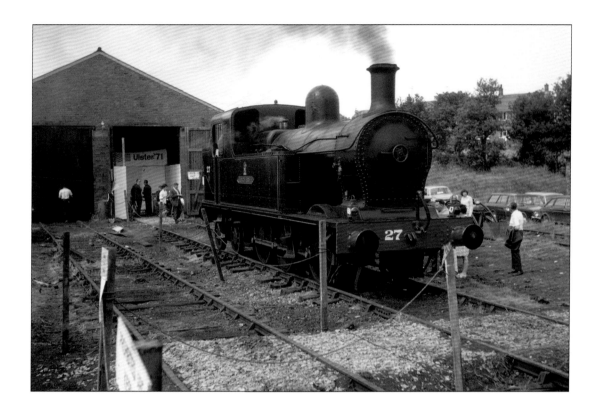

At Gortalea Junction on 24 June, A56R brings the Newcastle Goods off the Castleisland branch to resume its journey to Tralee. This class of diesel engine was a vast improvement over the old A Class for reliability and a breakdown where help was not close to hand must have been a nightmare.

A nice view of A49R on a long up goods at Ballyhaunis on 26 June. This station was towards the Claremorris end of the Athlone–Claremorris line.

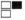

Back to Whitehead for the third Annual Open Day on 3 July 1971. I have included this slide because there was some recent debate about when No 27 was last steamed. She was *not steamed in 1970* (see page 129) but *she was steamed in 1971*, as seen here. The activity in the right-hand road, No 2, of the locomotive shed was a temporary chip shop set up by my friend Aldo Magliocco.

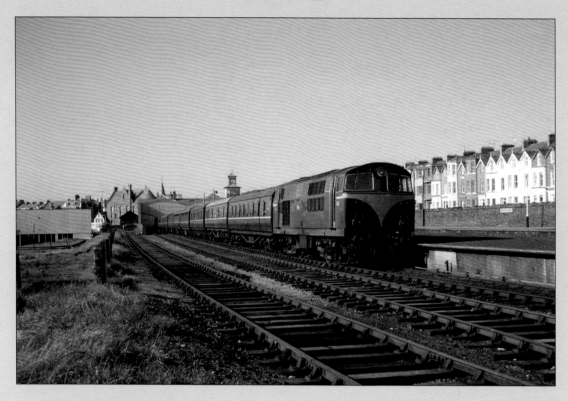

This possibly unique picture shows that NIR, as
late as 10 June 1972, could still put together a
locomotive-hauled Saturday excursion to Portrush.
The locomotive is No 101 and the ten vehicles on the
train date from the 1920s and 1930s, including some
North Atlantics. When the BUTs were withdrawn in
1975 a nine coach set made up of 121–129 replaced
this rake.

At Connolly station, Dublin, on 10 October 1972,
rebuilt C Class Metrovick No B211 engages in a bit of
station pilot work, using banner signals like those on
the right.

Now looking as if it is from another era, former
UTA Buffet Car 550 has taken up residence near the
works turntable at York Road. She had in sequence
provided catering on the Festival Express (1951–57),
the early MPD Derry expresses (1957–66) and the 70
Class expresses (1966–72). Now I suspect her working
life is over as NIR reduced catering to the Enterprise,
but she was soon to join the RPSI fleet as NCC No 87
and is still able to give us pleasure.

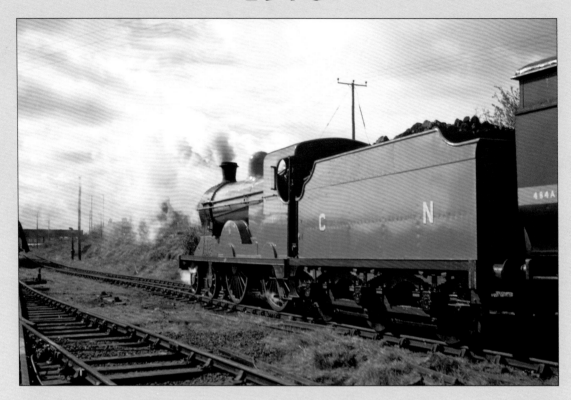

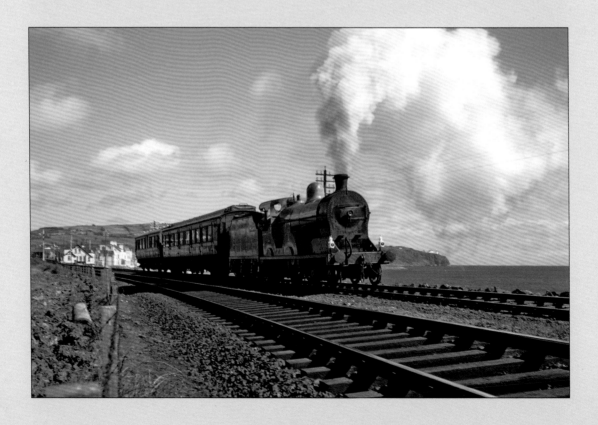

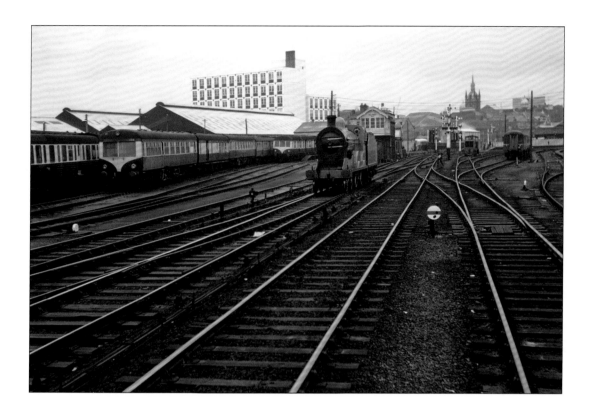

Now paired with a proper 3500 gallon D1 tender, No 171 *Slieve Gullion* has still to be lined out after a repaint but is already looking better than she did in the 1969–72 period. The photograph is at Whitehead on 28 April 1973. Note the RPSI's first coach, No 861, still numbered 484A and in CIÉ Departmental livery from her days on the Inchicore Works train.

With her full complement of two carriages, No 171 heads round towards the tunnel at Whitehead as part of a 'running in' trip. The carriages were 861 and the former GNR Directors' Saloon.

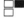

Here No 171 makes an appearance at Great Victoria Street on the RPSI Massereene Railtour on 12 May 1973. The predominant railcar types in the sidings are now BUT and MED. Some enthusiasts have claimed that Harlandic hauled the set out to release 171. I don't remember clearly but in this view I am *in the train*, it *has* been pulled out, *171 is running round* and there is no evidence that the resident DH shunter in the distance has turned a wheel!

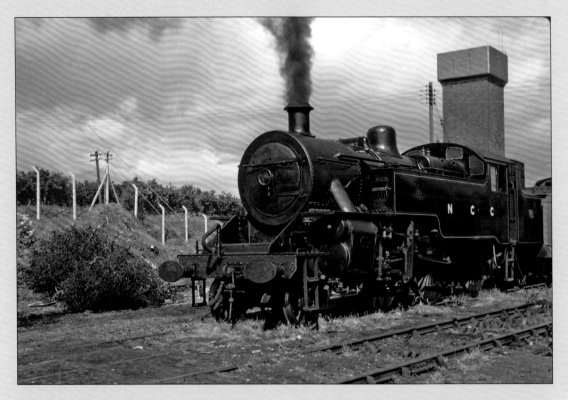

I want to conclude my last book with my first picture of NCC WT Class 2-6-4T No 4 in RPSI ownership, photographed on 7 July 1973 at the fifth RPSI Open Day at Whitehead. Although a GNR man through every bone of my body, the LMS was my favourite English railway of the big four and the Jeeps around Portadown were so much part of my childhood, so I was delighted when the RPSI saved a Jeep for posterity.

Other Colourpoint transport books by Norman Johnston

As author:

The Great Northern Railway in County Tyrone (1991)*

The Fintona Horse Tram (1992)*

Douglas Horse Trams (1995)

Locomotives of the GNRI (1999)

The Irish Narrow Guage in Colour (2003)

The Great Northern Railway (Ireland) in colour (2005)

Austerity Ulster 1947–51: Photos from the UTA Archive Vol 1 (2007)

Ulster in the 1950s: Photos from the UTA Archive Vol 2 (2008)

*Published by the West Tyrone Historical Society

As joint author:

Fermanagh's Railways (with Charles Friel, First edition 1998, Second edition 2008)

LNER Locomotives in Colour (with Ron White, 2002)

The Clogher Valley Railway (additional material to EM Patterson's original, 2003)

The Ballycastle Railway (additional material to EM Patterson's original, 2006)

The Mid Antrim Narrow Gauge (additional material to EM Patterson's original *The Ballymena Lines*, 2007)